G000123737

SANDYMOUNT

HUGH ORAM

The History Press Ireland

First published 2016

The History Press Ireland
50 City Quay
Dublin 2
Ireland
www.thehistorypress.ie

The History Press Ireland is a member of Publishing Ireland, the Irish
book publishers' association.

British Library Cataloguing in Publication Data.
A catalogue record for this book is available from the British Library.

ISBN 978 1 84588 882 4

Typesetting and origination by The History Press
Printed and bound in Great Britain by TJ International Ltd

CONTENTS

ACKNOWLEDGEMENTS

Firstly, I would like to thank my wife Bernadette for all her patience and understanding while I was working on this book.

The people who have been instrumental in making this book happen also have my thanks: Lorna Kelly of the Sandymount and Merrion Residents Association; Leo Sheeran, who supplied many old photographs; Delia Aherne; Dr Francis X. Carty; Michael Corcoran, for old photos of buses and trams from the National Transport Museum of Ireland; Anthony J. Jordan; Dean Lochner of the Bondi group; Marie Devlin; Mary B. Guckian; Brian O'Brien of Books on the Green, Sandymount; Michael and Rosa McAuliffe; Bridie Murphy; Brian Siggins; Petria and Yseult Thornley. I'm also indebted to Maria Gillen, Athlone, for all her encouragement while I was researching and writing this book.

I'm especially indebted to Bridie Murphy, Dr Francis X. Carty, Lorna Kelly and Brian Siggins for checking the captions before the book went to press.

In alphabetical order, I'd also like to thank the following people who helped: Valerie Adams (Presbyterian Historical Society of Ireland, Belfast), Nigel Bennett (Bennett auctioneers and estate agents), Charlie Bird, Books Ireland (Nick Maxwell and Tony Canavan), Rory Bracken (Castle Drive), Sister Monica Byrne (Irish Sisters of Charity, Sandymount), Ciarán Cooney (IRRS), Martin Cowley (Railway Union), Brendan Delany (ESB Archive and heritage manager), Dr Brian Denham, Bryan Dobson (RTÉ), Eric Donald (Teagasc), Enterprise Ireland (Alan Hobbs, Duncan Black and Fran McGrory), Róisín Fitzgerald (Rehab), Carmel Gilbride of Eredann (the life and times of Annie M.P. Smithson), Gerry Hampson (ESB Archives), Isaac Jackman (CD Shoes, Sandymount), Karen Keegan (formerly News Four), Alva Kelly (Books on the Green), Liam Kelly (National Transport Museum of Ireland), Tom Kennedy, Dermot Lacey (Dublin city councillor), John Loughran (Sandymount Hotel), Críostóir MacCarthaigh (archivist, National Folklore Collection, UCD), Alison Maloney (Teagasc), Sister Marie Bernadette (Irish Sisters of Charity, Sandymount), Sister Mary Gabriel (Irish Sisters of Charity, Kilmacud), Máirtín and Mary Mac Niocl, Anne and Colette MacSweeney, Joe McCarthy and Valerie Jennings (Sandymount Walking Trail), Susan McEntegart (Irish International advertising agency, Sandymount), Brendan McKenna (former Brunswick Press), Stephen McKenna of London (T.P. McKenna archives and website), Luke McShane (West Wood Club, Sandymount), Berni Metcalfe (National Library of Ireland), Sineád Murphy (Dublin city council media office), Jim Murray (Sea Safari), Margaret Pfeiffer, Barry Pickup (old railway photographs), Vincent and Rosarie Tierney, Pauline Tighe (Sandymount Avenue), Janice Crawford Walsh (Pembroke Cricket Club), and Frank Young (Pembroke Wanderers).

INTRODUCTION

Sandymount is a comparative newcomer in terms of Dublin suburbs, as it only started to develop in the mid-nineteenth century, after the arrival of the railway from Westland Row to Kingstown. The start of the trams in 1872 further helped its residential reputation. Yet despite that comparatively recent start, it has become a very distinctive place, with a strong village atmosphere, rather than an anonymous and characterless city suburb.

The place began life as brickworks, which were located where Sandymount Green is now sited and also further along the Merrion Strand area. Sandymount Green has been the green focal point of the village for 200 years and remains as popular as ever for the many festivities of the area, including the Wren Boys, the W.B. Yeats birthday commemorations and that most famous literary date of all, 16 June, Bloomsday.

Visitors are also enticed by Irishtown Nature Park, at the northern end of Sandymount Strand, which was developed from a derelict industrial site.

Sandymount has long attracted many writers, including Charles Kickham and Annie M.P. Smithson, and it is also the birthplace of W.B. Yeats. Strictly speaking, his birthplace is in Ballsbridge, but he is always thought of as a product of Sandymount. That other poet of world renown, the much more recent Seámus Heaney, is also always thought of as having been a Sandymount resident, whereas if the truth were known, his house is actually in Merrion. The Martello tower is a convenient dividing point between Sandymount and Merrion, although its potential remains undeveloped.

Besides a plethora of writers, Sandymount has long attracted people with theatrical connections, including Anew McMaster, Christopher Casson and Agnes Bernelle. Its convenience to RTÉ's Claire Byrne has also meant that Sandymount has had close connections with the national broadcaster right up to current times, with Claire Byrne, a broadcaster of distinction, being a Sandymount resident. Ivan Yates, a former bookie-shop owner and politician turned broadcaster, on Newstalk and TV3, also lives in Sandymount.

Sandymount also has an amazing sporting history, with such distinguished cricket clubs as Pembroke, YMCA and Railway Union, famed not just for cricket but rugby, tennis and other sports too. Pembroke Wanderers' Hockey Club has an equally lively and long-held reputation. Yet Sandymount has only briefly had a GAA club and these days the Clanna Gael GAA club is at Seán Moore Park in Irishtown, right on the fringes of Sandymount, although of course it attracts many Sandymount members. The Aviva stadium is also right on the borders of Sandymount.

The various architectural styles of Sandymount show its progression, from the grand mid-Victorian houses of Claremont Road, Park Avenue and other thoroughfares to the many roads built up during the 1930s, such as Farney Park, and plenty of house and apartment developments, as well as infill buildings,

in recent decades. All the changes in and around Sandymount village in recent years can be seen in the way the retail and restaurant environment bordering Sandymount Green has come on so much.

In short, Sandymount is a fascinating suburb in its own right, fast changing but always true to its origins. In the pages of this book, I've tried to show as many aspects of its ongoing development as possible and note some of the outstanding personalities, past and present, who have made Sandymount what it is today. I haven't always stuck to a strict interpretation of Sandymount's boundaries, but all things included have a link to the area.

1

SANDYMOUNT GREEN

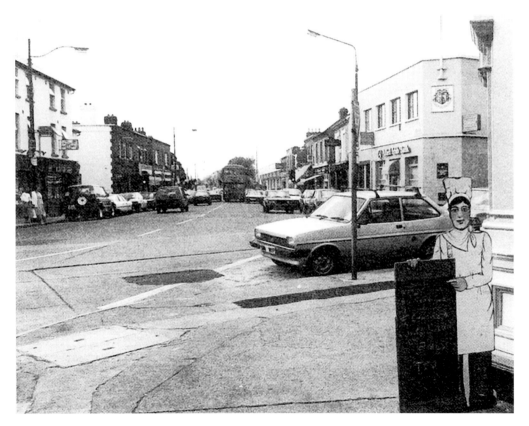

Sandymount Green in the 1970s, with AIB on the corner of Seafort Avenue and Sandymount Road. The lamppost at the corner has long since disappeared. (Courtesy of Leo Sheeran)

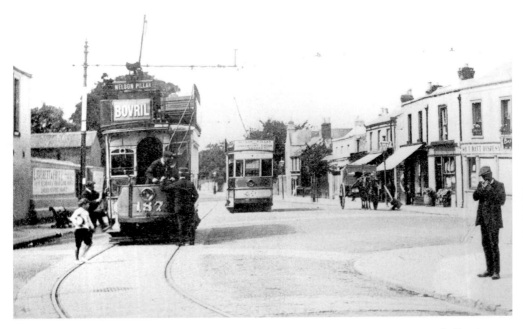

Trams on Sandymount Road, approaching the Green, about 100 years ago, with Batt's chemists clearly visible on the corner of Sandymount Road and the Green. The No. 2 tram ran from Nelson's Pillar at the GPO, via Ringsend and Irishtown, as far as Sandymount Green. (Courtesy of Leo Sheeran)

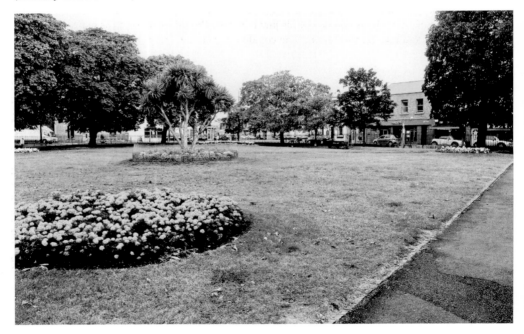

A view of some of the present-day flowerbeds in Sandymount Green, a popular recreational spot for local people.

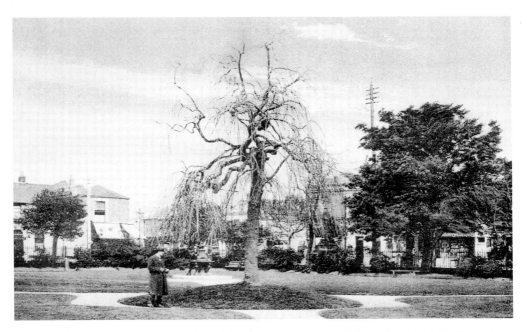

Sandymount Green in earlier days. The chestnut trees round the perimeter of the Green have long been in place, having been planted by the inhabitants of Sandymount Castle; the railings around the Green have been similarly positioned. In the early 1950s, those railings were the scene of a great tragedy when an 11-year-old boy called Larry Browne, from the locality, who was climbing a horse chestnut tree to collect conkers, slipped and fell onto the railings. A spike on the top of the railings penetrated his jaw and even though onlookers rushed to lift him off the railings and take him to hospital, he couldn't be saved. (Courtesy of Leo Sheeran)

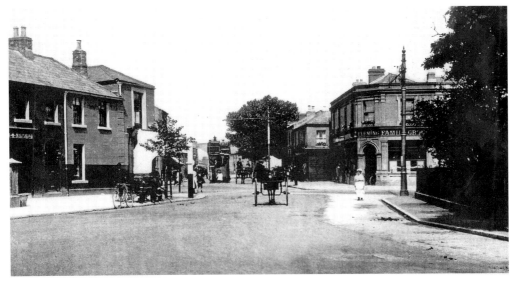

Another old-time photograph showing the Green at the junction with Claremont Road and Seafort Avenue in the 1900s. (Courtesy of Leo Sheeran)

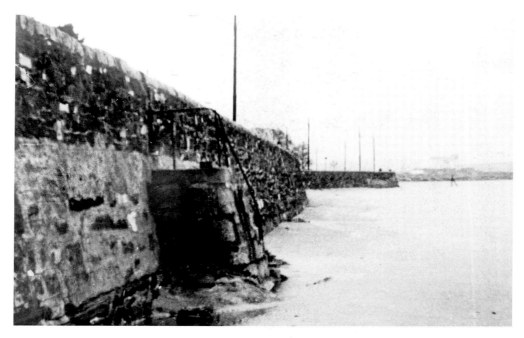

The old sea wall along Strand Road, before the present walkway was built in the early 1970s.
(Courtesy of Lorna Kelly)

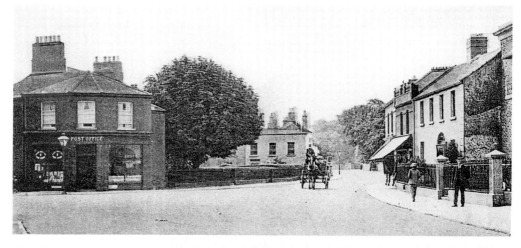

This photograph, taken just over 100 years ago, shows the foot of Claremont Road where it
joins Sandymount Green. The right-hand side of Claremont Road has changed substantially
in recent times, with the construction of tax offices and new houses, but the houses on
the left-hand side remain much as they were. The building on the left-hand side of the
photograph, next to the large tree, was the local post office for many years, run by Miss
Murray. For over a decade now the building has been occupied by Bennett's, the estate agents
and auctioneers. As for the post office in Sandymount, it had several subsequent locations but
in early 2015, the post office on Sandymount Road, just down from the Spar supermarket,
closed down, causing local residents much inconvenience. (Courtesy of Leo Sheeran)

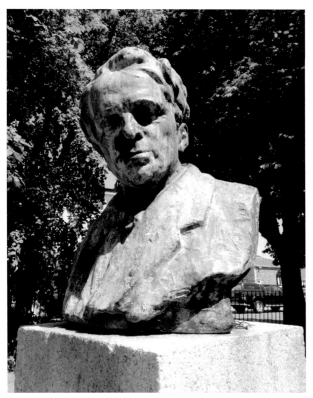

The bust of W.B. Yeats on Sandymount Green. His family had a long connection with Sandymount; his grandfather, Revd William Butler Yeats, had retired from his living at a parish near Portadown and came to live in Sandymount, where his brother-in-law, Robert Corbet, a merchant, owned Sandymount Castle. The Revd Yeats died at Sandymount Castle in 1862, when he collapsed after lunch one day. The father of W.B. Yeats, the poet John B. Yeats, had married Susan Polloxfen in Sligo in 1863 and they settled in a six-roomed semi-detached house at No. 5 Sandymount Avenue, where W.B. Yeats was subsequently born. The renowned poet took his first outings in a pram pushed by his nurse in the grounds of Sandymount Castle and she reported that he was much frightened by the sight of the deer.

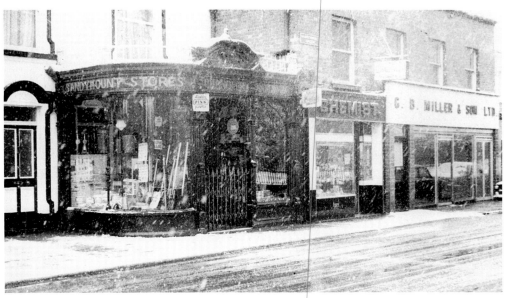

The north side of Sandymount Green, seen during a snowstorm in the 1980s. At that time, that side of the Green had a large, uninspiring shopfront belonging to a packaging firm, G.B. Miller. (Courtesy of Lorna Kelly)

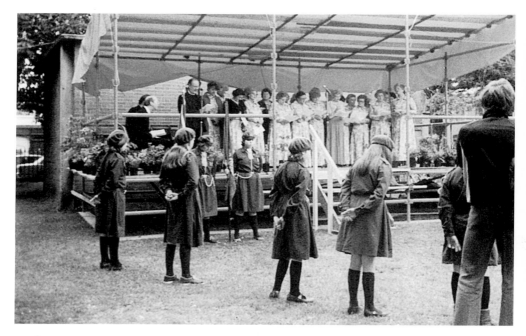

Sandymount Green during the first Community Week, 1982, with local girl guides in front of the stage. That first Community Week was the brainchild of the Sandymount & Merrion Residents' Association and was organised and run by a small committee chaired by Tony Reid. The various clubs and organisations in the area each ran an event. The start-up of Community Week also owed much to the diligence of Terry Vaughan, who worked for Dublin Corporation. She had returned home to Ireland after living in the US and she helped many communities across Dublin, including Sandymount, develop community festivities. The permission of the old Dublin Corporation was essential, since it owned Sandymount Green. Since then, it and the annual Tidy Towns contest have provided much reason for community co-operation in Sandymount, with the help of Dublin City Council. (Courtesy of Delia Aherne)

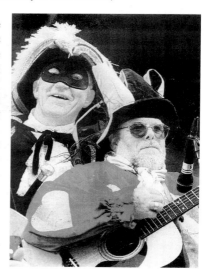

Seen at one of the Wren Boys festivities in Sandymount in the 1980s are Michael McAuliffe, master of ceremonies, and Mick Power from the Swords Mummers. Today, more than 30 years after the festival was started, it remains very popular on St Stephen's Day, with many festivities on Sandymount Green. (Courtesy of the late Austin Finn)

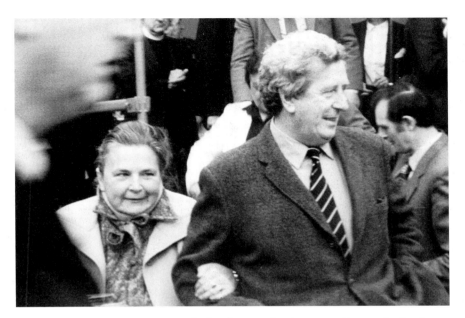

During that first Community Week, local TD and subsequent Taoiseach, Dr Garret FitzGerald, with his wife Joan, visited Sandymount. The summer of 1982 was an in-between time for him politically. He had been Taoiseach from July 1981 until February 1982, then he was elected Taoiseach again in December 1982 and remained in the job until March 1987. (Courtesy of Lorna Kelly)

Sandymount Green a century ago. It has changed surprisingly little since; the chestnut trees are still in place, although the Green now has a number of very colourful flowerbeds. The Green had been laid out in the early nineteenth century as the nucleus of the then developing village; previously, since the late eighteenth century, one of the area's brickworks was located on the site of the Green, while the other was close to Merrion Strand. As a result of all those brickmaking activities, begun in 1760, Sandymount's original name was the prosaic Brickfield Town. Sandymount Green, a mere 0.3 hectares in size, was for a long time part of the Pembroke estate, but in the 1960s, it was taken over as a public park by Dublin Corporation. (Courtesy of Leo Sheeran)

Above and below: January 1982 saw exceptionally heavy snow that lasted for a week in Dublin; it was so heavy that Dublin Airport was closed for the duration. These photographs show snow beside Sandymount Green and piled up on the main railway line through Sandymount, beside Serpentine Terrace. (Courtesy of Yseult Thornley)

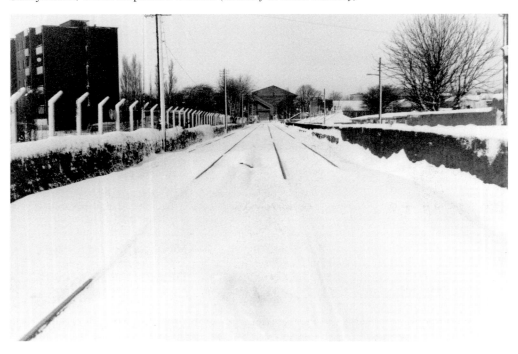

2

STRAND
ROAD

Before the present walkway was built between Sandymount Strand and Strand Road, in the early 1970s, this was the footpath that had existed before its construction. (Courtesy of Lorna Kelly)

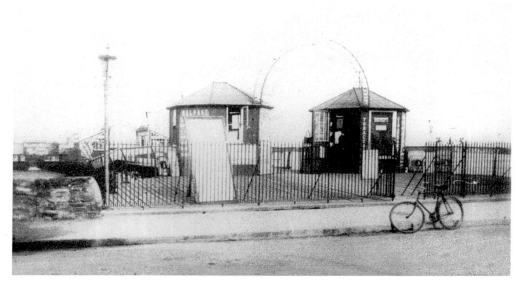

The entrance to the old pier on Strand Road. The pier had been built immediately after the seawater baths had opened in 1883; the pier was ceremoniously opened in 1884, the work of the Merrion Baths and Pier Company. The entrance to the pier had an ornamental arch with kiosks on either side. At both the entrance to the pier and along its length, Victorian knicknacks were sold, alongside snacks. These included cockles and whelks dug up from the strand.

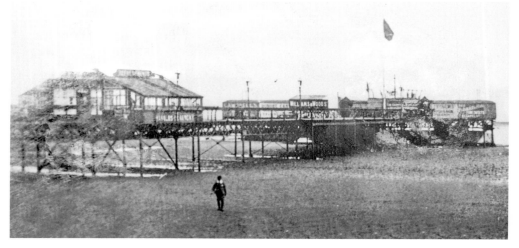

The latticework pier ran for a mere 75 metres, from the Strand Road as far as the seawater baths. It was the only pier of its kind in Ireland and was considered to have been the shortest pier in these islands. Halfway along the pier was a bandstand; concerts by military bands were a regular feature here on Tuesday and Saturday evenings during summer. The pier only had a brief existence, despite its early popularity. In 1920, it was demolished and the component parts sent to the Hammond Lane scrap yard in Ringsend. Only the foundation of the seawater baths remains to this day and although there has been talk in recent years of reinstating the pier, its reconstruction remains unlikely.

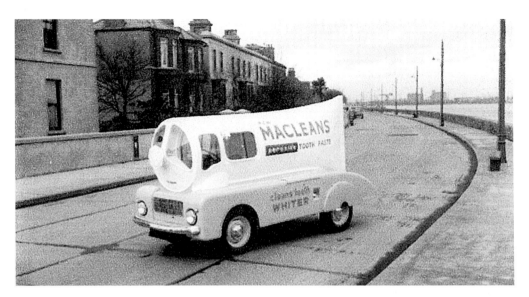

This Macleans toothpaste car, very uncomfortable for the driver, was pictured whizzing along Strand Road in 1960, an early example of an outdoor advertising stunt. (Courtesy of Leo Sheeran)

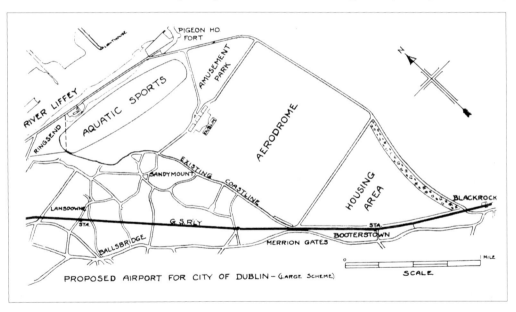

PROPOSED AIRPORT FOR CITY OF DUBLIN – (LARGE SCHEME)

In 1935, an elaborate plan was drawn up for turning Sandymount Strand into an airport for Dublin; a similar scheme was also proposed for the Phoenix Park. Both were short lived and by the following year, Collinstown, just north of Dublin, had been chosen as the site for Dublin Airport, a decision that turned out to have been far more fortuitous. While Sandymount Strand might have been suitable for the short-range piston-engined aircraft in use in the mid-1930s, it would have been totally unsuitable for today's jets. In more recent times, controversy has raged over plans to dig a tunnel under Sandymount Strand for an eastern bypass. (Illustration from *Dublin Airport: The History, 1940-1990*, by Hugh Oram)

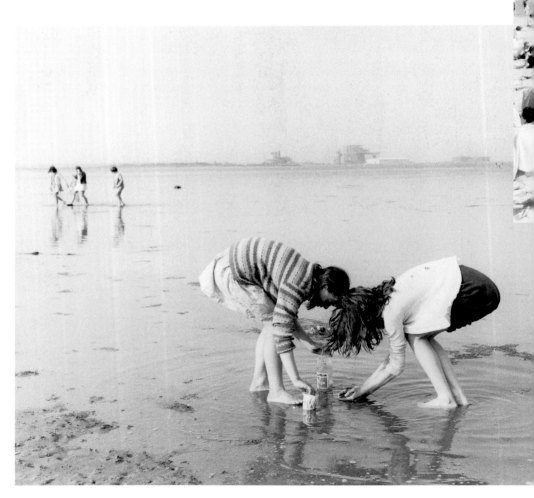

Two young girls playing in the wet sand on Sandymount Strand, presumably examining the wildlife, including cockles and mussels. (Courtesy of Leo Sheeran)

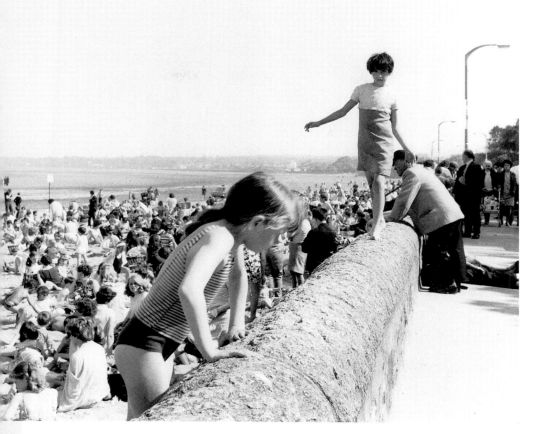

Two young children on the old sea wall at Strand Road; the photograph was taken in the 1960s, before the present walkway was built. Crowds of people can be seen on the beach, to the left, enjoying the sunshine, in an era where foreign package holidays were only starting to come into vogue. They had come not just from the local area, including Irishtown and Ringsend, but also north and west Dublin. (Courtesy of Leo Sheeran)

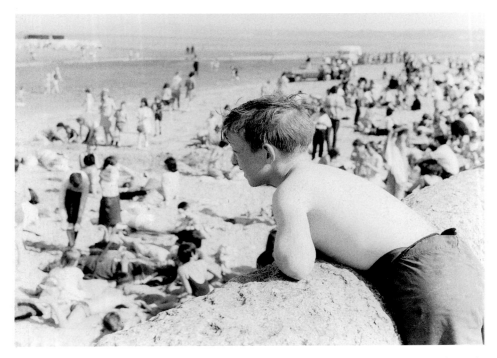

A young boy leaning on the sea wall at Strand Road and gazing over the mass of people sitting on the strand enjoying the sea air. The photograph was taken during the 1960s. (Courtesy of Leo Sheeran)

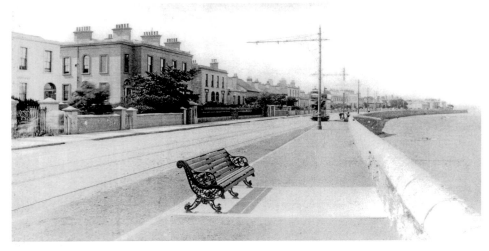

Strand Road looking delightfully empty of traffic, *c.* 1900; even the bench, overlooking the strand, is deserted. One of the houses in the terrace on the left-hand side, just opposite the large pole for the tramway electricity supply, had been frequently visited up to 1900 by Percy French, the singer, songwriter and watercolour artist, before he left for London. One of his close friends from his days as an engineering student lived on Strand Road, while Percy French himself lived at St John's Road for a while. (Courtesy of Brian Siggins)

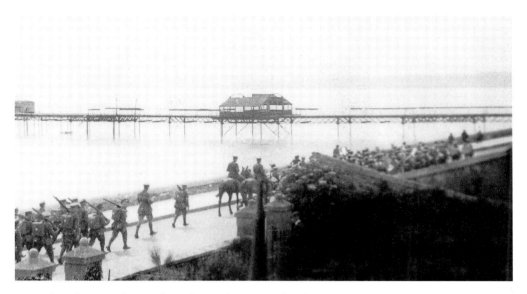

This photograph must have been taken immediately prior to 1920, as Sandymount pier in the background was demolished in 1920. British soldiers were marching along Strand Road, having come from the fortress on the Poolbeg peninsula that had just been closed. They were headed towards the harbour at Kingstown, now Dún Laoghaire. Some sources say that the pier wasn't demolished until 1923, and that this photograph shows the troops leaving in 1922. (Courtesy of Leo Sheeran)

Strand Road in recent times. One famous Strand Road resident was Anew McMaster, the last of the fit-up managers, who lived at No. 57. In the old days, when theatre companies travelled the country, they were called 'fit-ups' because the stages they played on were fitted out in a matter of minutes. Anew started on the road in 1915, a tradition he continued for nearly 45 years. He set up his own Intimate Shakespeare Company in 1925 which he kept going for decades. He entertained many of the theatrical greats in his house in Sandymount, including Micheál MacLiammoir, Hilton Edwards, Dame Sybil Thorndike, Cyril Cusack and Noel Coward. Ironically, Anew McMaster died in 1962, the same year that Irish television started.

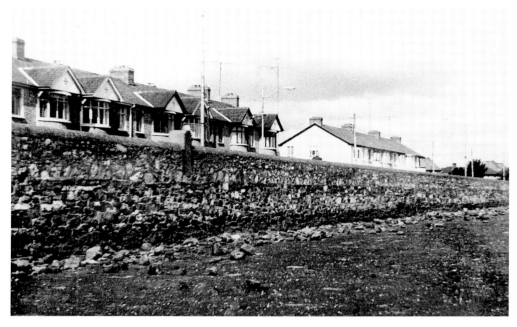

The old sea wall where Strand Road merges into Beach Road; the photograph was taken before the development of the present sea wall, in the early 1970s.

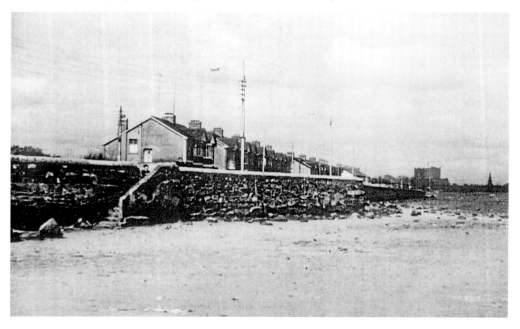

Beach Road at the Irishtown end, during the 1960s, before the road was widened. The road had been walled off from the sea in the 1920s but it wasn't until the 1940s that the sea wall was extended, the area behind it was in-filled and Beach Road became a through road. As late as 1954, it was still seen as part of Sandymount Strand. (Courtesy of Lorna Kelly)

3

MARTELLO
TOWER

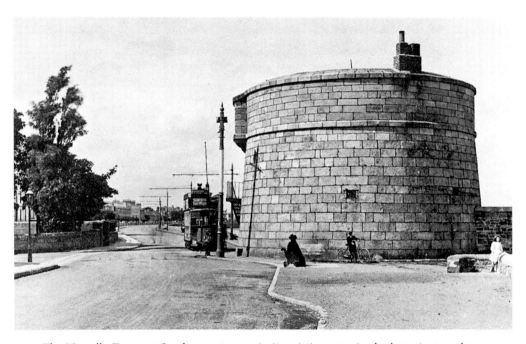

The Martello Tower at Sandymount, seen in its pristine state in the late nineteenth century, before alterations were made. A total of fifty of these towers were built around the Irish coast in the early nineteenth century to protect against the threat of a Napoleonic invasion, which never happened; twenty-eight of them were built in the greater Dublin area and the one in Sandymount dates from 1804. When the Dublin Tramways Company began a service between Sandymount and Nelson's Pillar in 1872, it bought the tower for £520. It became the terminal for the Nos 3 and 4 trams, while inside the tower was a waiting room for passengers and an apartment for the caretaker. (Courtesy of Leo Sheeran)

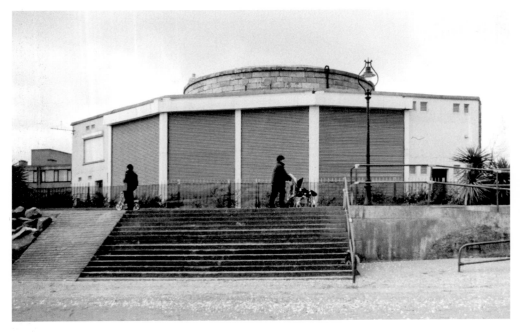

Martello Tower in recent times. After an abortive attempt to reopen the tower as a restaurant over 20 years ago, the building has remained derelict, with shutters firmly in place. (Courtesy of Lorna Kelly)

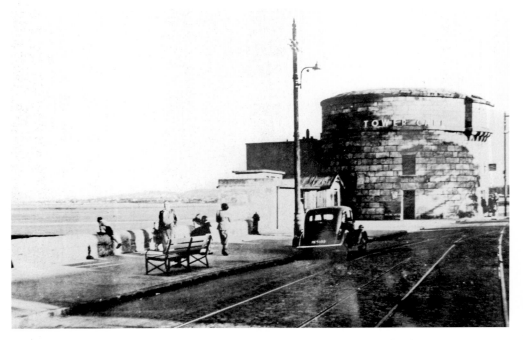

The Martello Tower on Strand Road, probably during the 1940s, as a pole for the supporting the overhead power lines for the trams is still in place. (Courtesy of Leo Sheeran)

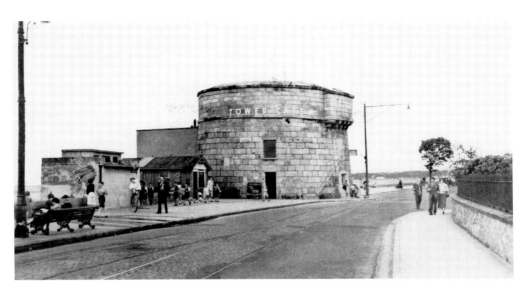

The Martello Tower on the Strand Road, pictured during the tram era, when the tower was the terminus for the Sandymount end of the Nos 3 and 4 tram routes. (Courtesy of Leo Sheeran)

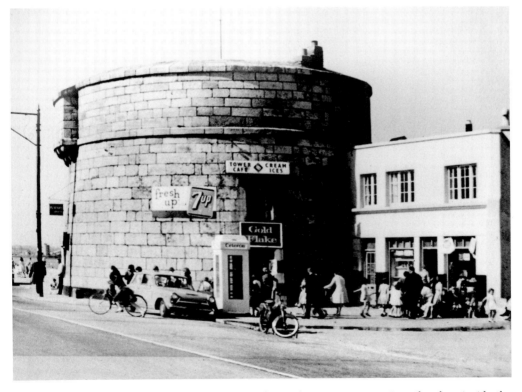

The Martello Tower seen around 1970, with people queuing to get into the shop inside the tower, while the modern block, including shop, to the right of the tower, since demolished, also had people queuing up to get in. (Courtesy of Lorna Kelly)

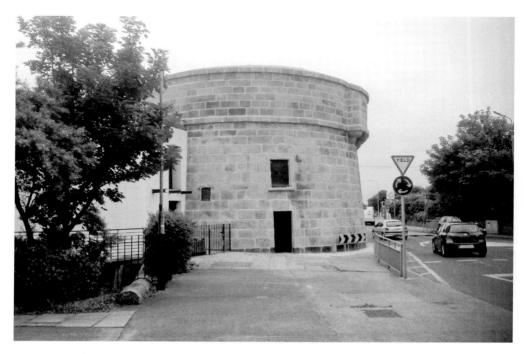

Above and below: Part of the modern extension to the Martello Tower in Sandymount. (Courtesy of Lorna Kelly)

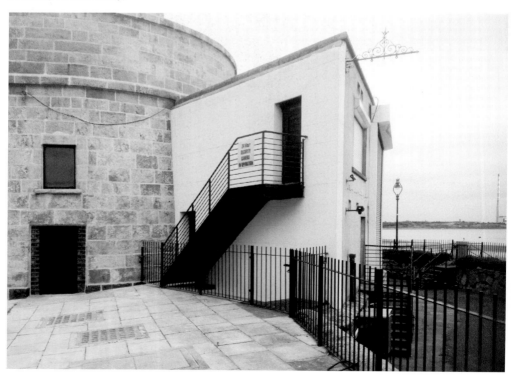

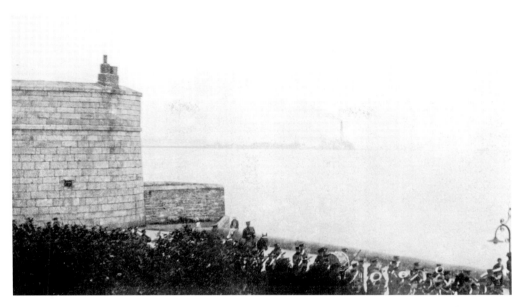

British soldiers, including bandsmen, pictured beside the Martello Tower in Sandymount at some point just before 1920. (Courtesy of Leo Sheeran)

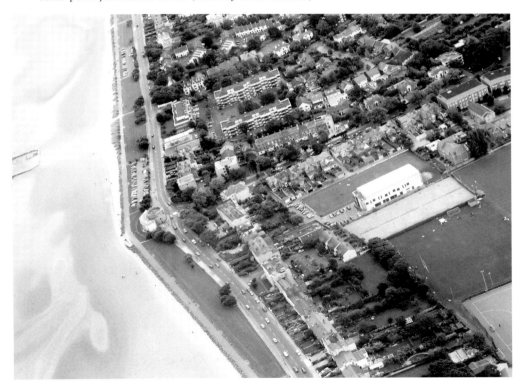

An aerial view of Sandymount Strand, with the Martello Tower clearly visible. Strand Road can also be clearly seen, while the road leading away from the tower is St John's Road.

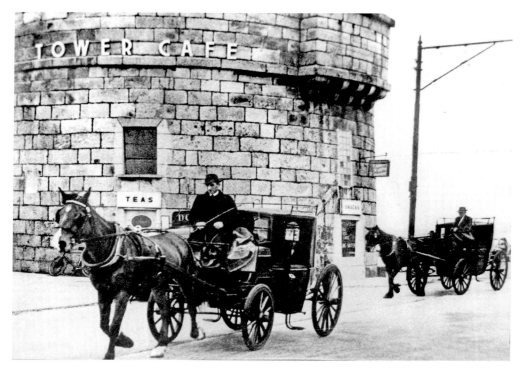

A jarvey with horse-drawn hansom cab outside the Martello Tower, with a similar cab in the background. When the tower was a tram terminus, jarveys plied a useful trade with passengers alighting from the trams.

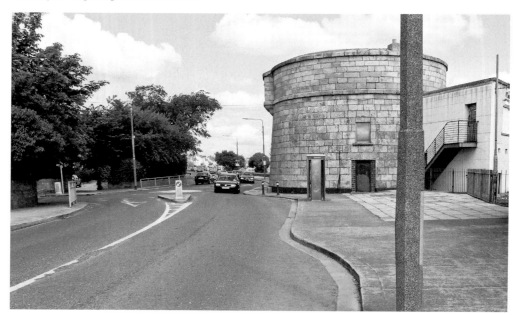

The Martello Tower as it looks in present-day Sandymount.

4

SANDYMOUNT STRAND

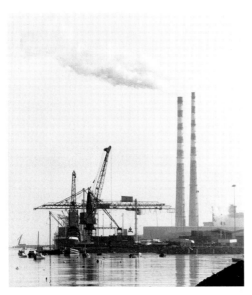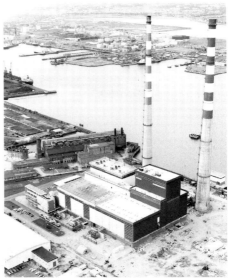

The old ESB chimneys have stood guard over the northern side of Sandymount Strand for less than fifty years, yet they have become an indelible part of the land and seascape. The first of the twin red and white chimneys for the Poolbeg generating station was built in 1971, while the second was completed in 1978. One is slightly higher than the other; No. 1 chimney is 207.48 metres tall, while No. 2 is 207.80 metres in height. The chimneys were taken out of use in 2010 when the old oil-fired generating station closed down and concern grew that these iconic emblems of the city, visible from many parts of Dublin and from aircraft coming in to land at Dublin Airport, would be demolished. There has been much public interest in seeing the chimneys remain in place and the ESB is taking measures to protect and preserve the twin structures. (Courtesy of ESB Archives)

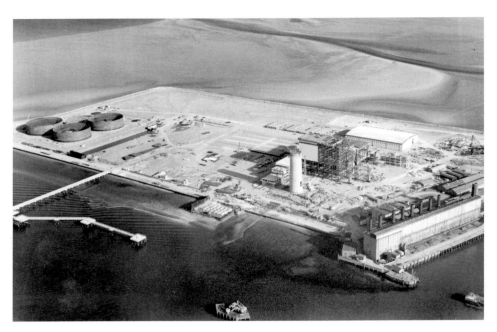

Above and below: The Poolbeg peninsula, to the immediate north of Sandymount Strand, has long been connected with electrical generation. The City of Dublin Electricity Works opened at the Pigeon House site in 1903 and continued as Dublin's main source of power until the 1950s. In the 1970s the ESB then began development of its Poolbeg generation station; the start of that work is seen in the upper photograph. It shows the then new oil-fired power station and the first of the chimneys being built. The lower photograph shows the first chimney and the power station, following their commissioning in 1971. The Poolbeg station started to run on natural gas from Kinsale in 1984. The ESB station at Poolbeg was subsequently further upgraded, in 2000, to use combined gas cycle technology,while the original three oil-fired units at the Poolbeg plant were taken out of service in 2010. (Photographs courtesy of ESB Archives)

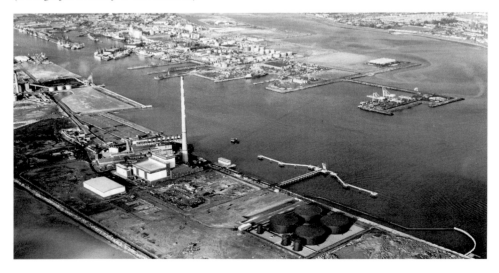

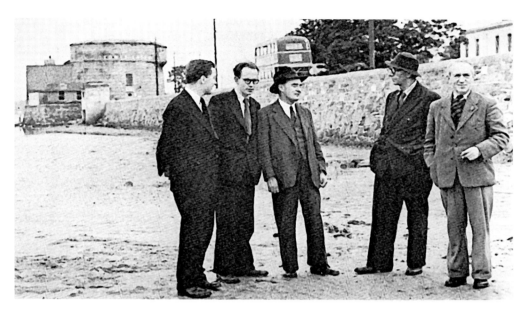

When the first Bloomsday was organised in 1954, a group gathered on Sandymount Strand. From left: John Ryan, writer and broadcaster; Anthony Cronin, writer; Flann O'Brien (Myles na Gopaleen); Patrick Kavanagh and Tom Joyce, brother of James Joyce, whose masterwork *Ulysses* had been set in the Dublin of 1904, with many references to Sandymount. James Joyce had stayed at No. 35 Strand Road, Sandymount, on 1 and 2 September 1904, with a friend, James H. Cousins. On 16 June 1904, the date on which he set his novel, *Ulysses*, Joyce spent the day at a house in Dromard Terrace, just off Sandymount Green. (Courtesy of *The Irish Times*)

Two young boys play on Sandymount Strand in the 1960s, bucket and spade at the ready. (Courtesy of Leo Sheeran)

For many people, this Elinor Wiltshire photograph, taken in the 1970s, is their favourite shot. It shows a young child playing on Sandymount Strand. (Elinor Wiltshire Collection, National Library of Ireland)

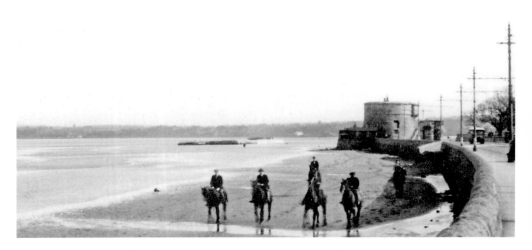

An old photograph of four horses being exercised on the strand. Even though it's getting on for fifty years since Sandymount had riding stables, the strand is still popular with horse riders. (Courtesy of Leo Sheeran)

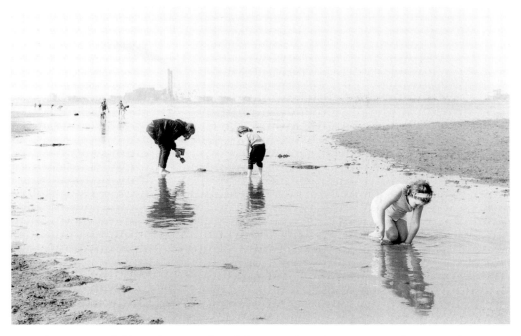

Three young children playing in the tidal waters of Sandymount Strand, again in the 1960s.
(Courtesy of Leo Sheeran)

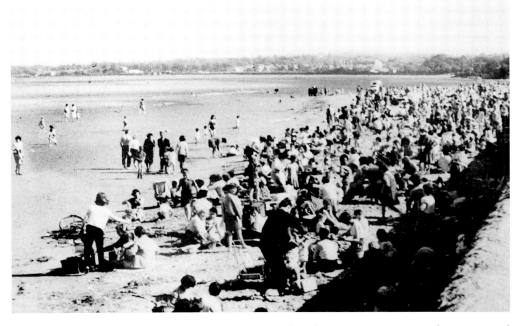

Crowds enjoying the sun on Sandymount Strand in the 1970s. Many came from Ringsend
and Irishtown, as well as from further afield, including Dublin's north side and Ballyfermot
and Crumlin on the west side of the city, thanks to the No. 18 bus. (Courtesy of Leo Sheeran)

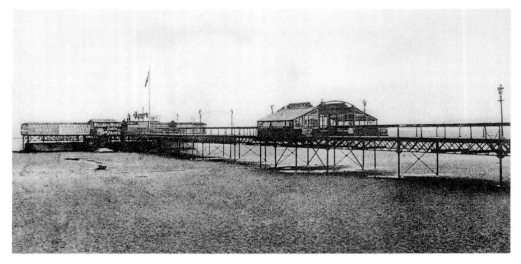

The old pier at Sandymount strand opened in 1884 and proved remarkably short-lived, despite its initial popularity. It was taken down in 1920, although some sources say it wasn't demolished until 1923. At a mere 75 metres long, the steel structure was often described as the shortest pier in these islands. (Courtesy of Leo Sheeran)

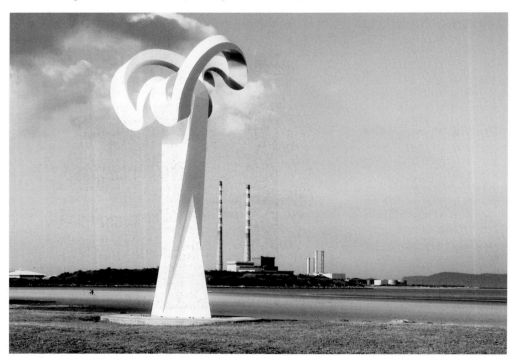

The striking modern sculpture on the grass beside the walkway on Sandymount Strand. It was the work of a Mexican sculptor known as Sebastián and was donated by the Mexican Government to the city of Dublin. It was unveiled beside the Strand in November 2002, and remarkably, has remained free of graffiti or the attention of vandals.

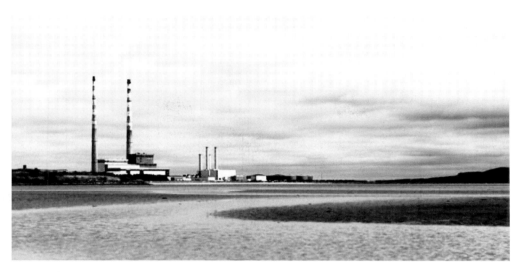

A fine shot showing the spacious expanse of beach at Sandymount Strand, beneath a cloud-filled sky, with the twin chimneys of the ESB standing sentinel.

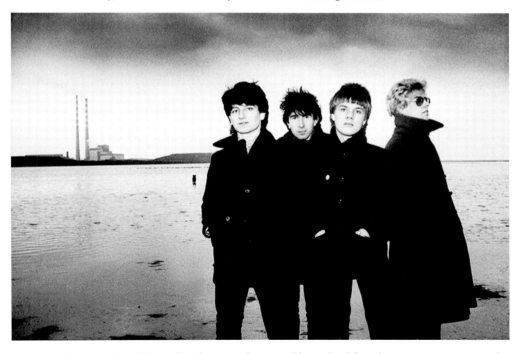

Sandymount Strand has often been used as a publicity backdrop by many groups over the years. This photograph, taken in 1980, shows U2 lining up for a photograph on the strand. U2 was formed in Dublin in 1976 and in the decades since, has become one of the most recognised groups in the world, as well as one of the wealthiest. From left: Bono (vocals and guitar), The Edge (guitar, keyboards and vocals), Larry Mullen junior (drums and percussion) and Adam Clayton (bass guitar). (Courtesy of iowa2ireland.blogspot.com)

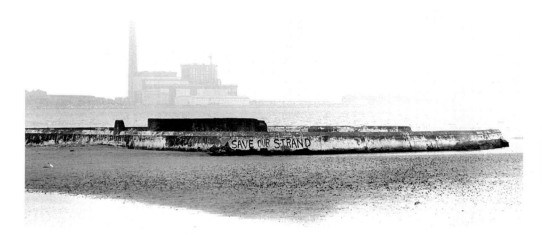

The foundations of the old seawater baths on Sandymount Strand – which opened in 1883 – still exist, defying the elements and the work of graffiti artists.

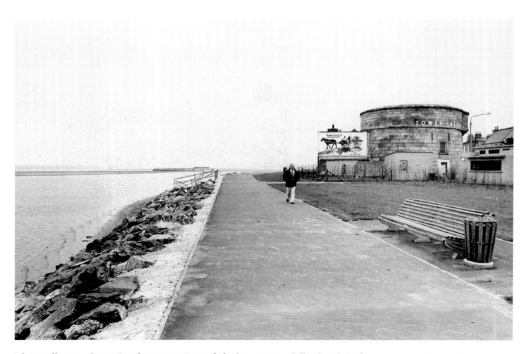

The walkway along Sandymount Strand, before it was fully developed. (Courtesy of Lorna Kelly)

A charming photograph, taken about forty years ago, showing a young boy and a dog on the strand. (Courtesy of Lorna Kelly)

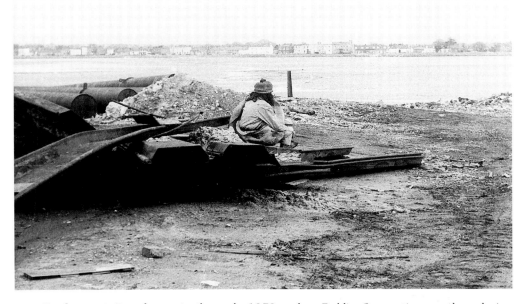

Sandymount Strand seen in the early 1970s, when Dublin Corporation was busy laying drainage pipes beneath the strand. The unnamed homeless man seen sitting at the site of all this work was a frequent sight at the time; he used one of the workmen's huts for his living room and another for his kitchen. (Courtesy of Lorna Kelly)

Walkers on Sandymount Strand over forty years ago, before the present walkway was developed.

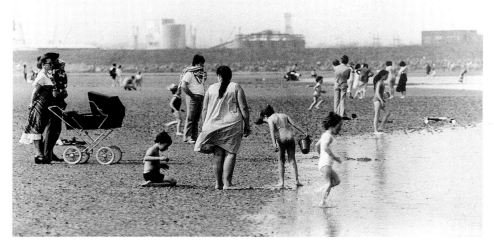

Families gathered on the beach at Sandymount Strand, close to the Irishtown end of the strand, some time in the early 1970s. At the time, much of the land on the Poolbeg peninsula, in the background of the photograph, was used by the Corporation for dumping rubbish. That land now forms the Irishtown Nature Park, the creation of which began in the 1980s. Immediately behind the nature park, the highly contentious incinerator is being constructed, due to become fully operational by 2017. In the old days, according to Jim Murray, who runs Sea Safari trips on the River Liffey, the ESB at Poolbeg maintained a rescue boat that was used to retrieve people who had got into difficulties with the fast-moving tides on Sandymount Strand. These days, coastguard helicopters perform the same duty and have carried out some dramatic rescues in recent years. (Courtesy of Lorna Kelly)

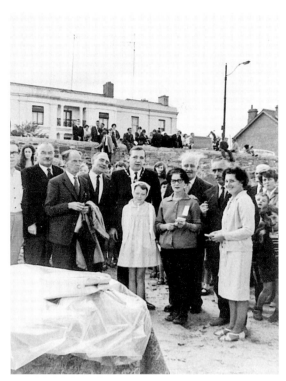

Families gathered on the strand, just below Strand Road, in 1968, to protest against the plans by Dublin Corporation to widen the road. Despite the protests, the road widening went ahead.
(Courtesy of Lorna Kelly)

On Sunday, 8 January 2006, visitors to Sandymount Strand were mesmerised by the sight of 400 discarded Christmas trees planted in the sand by Barbara Nealon and Tara Kennedy, both of whom had recently graduated from art school. About sixty of the trees came from houses in the locality, while the remainder were sourced in the Christmas tree collection centre on one of the car parks at Sandymount Strand. The sight was fleeting; the trees were removed the following day.

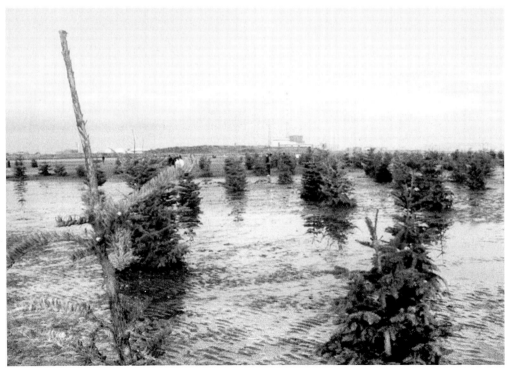

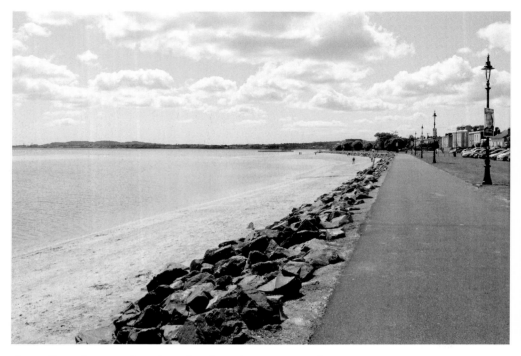

The walkway between Strand Road and Sandymount Strand in recent times.

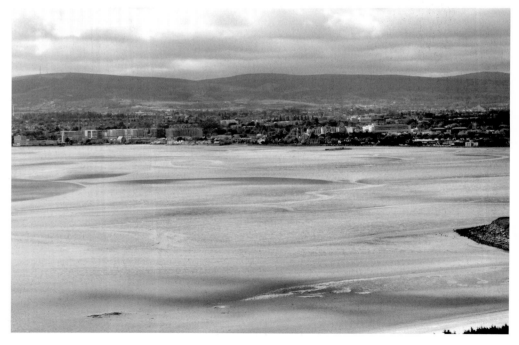

A fine photograph looking across Sandymount Strand, with the Dublin Mountains in the background.

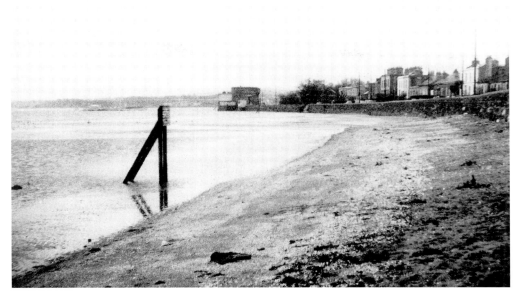

Sandymount Strand at high tide, with the tower in the background, before the present-day walkway was built.

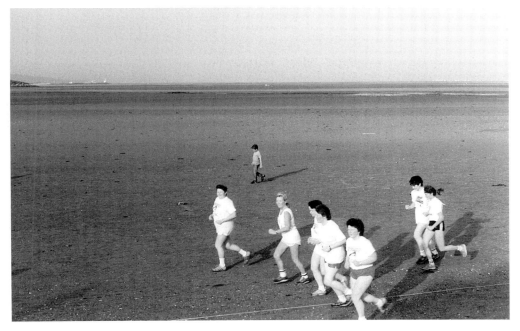

A Bloomsday race across the sands of Sandymount Strand, 1978. The runner on the far left is Christina Guckian, sister of Mary B. Guckian. (Courtesy of Mary B. Guckian)

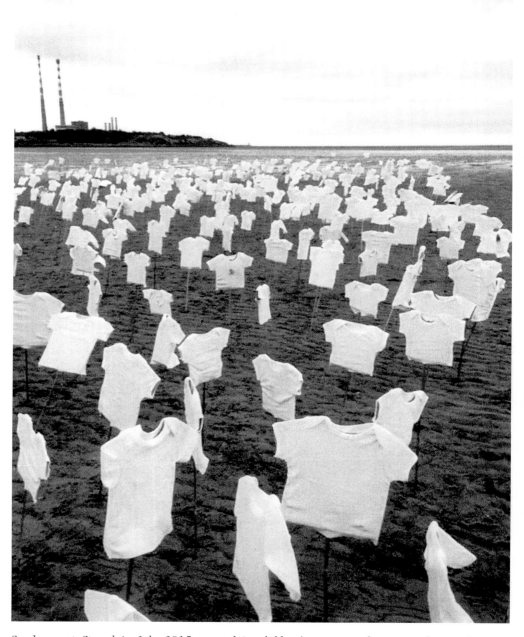

Sandymount Strand in July 2015 covered in children's vests, stuck on uprights in the sand, 556 in all, commemorating the Palestinian children killed in Gaza during the Israeli bombardment of the territory in July 2014.

5

TRANSPORT

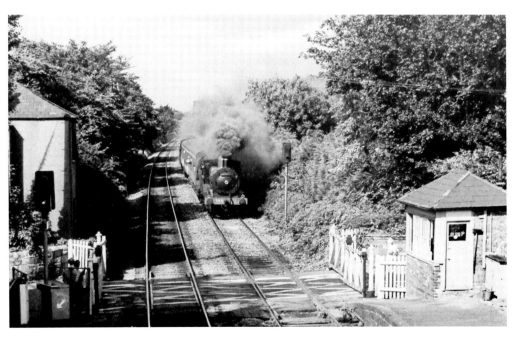

Steam trains vanished from the mainline railways in the early 1960s, but their sight, sounds and smells haven't gone from Sandymount in the years since. Sandymount is on the main line from Dublin to Wexford and Rosslare and from time to time, the Railway Preservation Society of Ireland runs steam excursion trains on this route. This train was seen in 1978, approaching the level-crossing gates at Sydney Parade station, billowing clouds of black smoke and steam. (Courtesy of Barry Pickup)

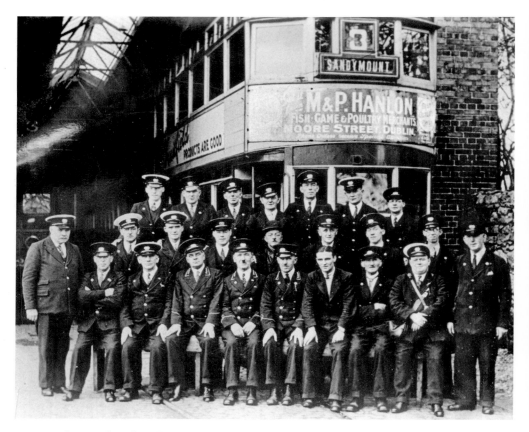

Tram workers gathered at the old tram depot in Gilford Road in 1937. Little more than a decade later, the tram network in Dublin closed down and the Gilford Road depot was put to other commercial uses. The very tall man in the back row is Joseph Sheeran, a tram driver who subsequently became a bus driver. He was the father of Leo Sheeran, a well-known native of Sandymount, who now runs a company called Video Productions. Horse-drawn trams to Sandymount had been established in 1872 and were electrified in 1900. The Nos 3 and 4 tram routes, as far as Sandymount's Martello Tower, closed down on 7 February 1938 and soon after, the track from the tower to the depot was taken up. However, a very small section of track from Gilford Road into the depot still exists. On 26 March 1940, all trams to and from Sandymount were replaced by buses. (Courtesy of Leo Sheeran)

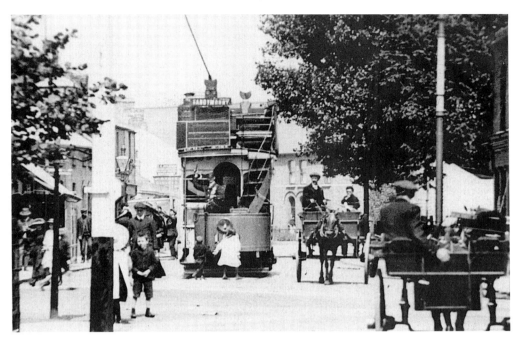

Around a century ago, the main means of getting around Sandymount, other than by walking or cycling, were by pony and trap or by tram. This photograph shows both modes of transport from that era. In more recent times, many people from outside the area depended on public transport to bring them to the strand in Sandymount, such as the No. 18 bus, which carried many people from the Ballyfermot area. (Courtesy of Leo Sheeran)

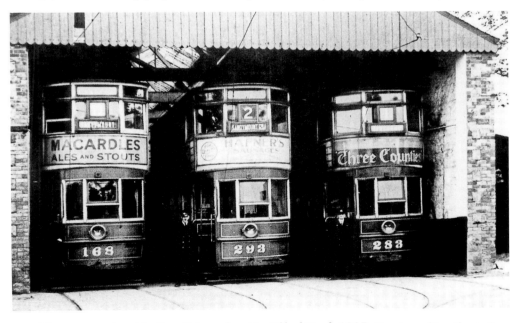

Three trams at rest in the old tram depot in Gilford Road, 1937. (Courtesy of Leo Sheeran)

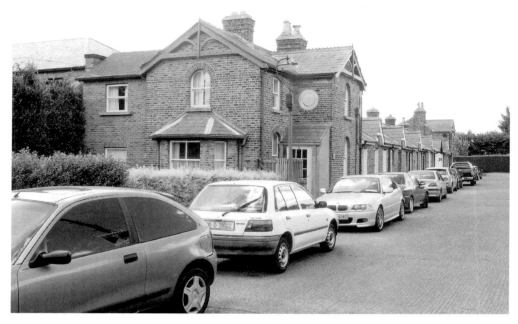

The old tram workers' cottages at Gilford Terrace, adjacent to the old tram depot. The cottages have been much refurbished in recent years. (Courtesy of Leo Sheeran)

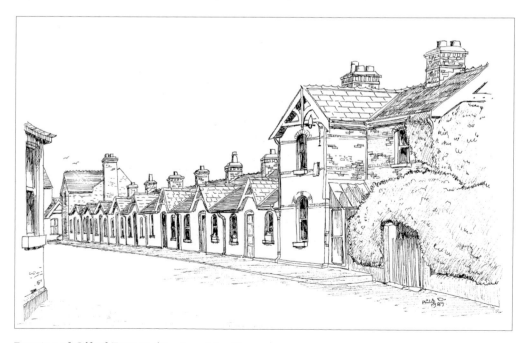

Drawing of Gilford Terrace. (Courtesy of Leo Sheeran)

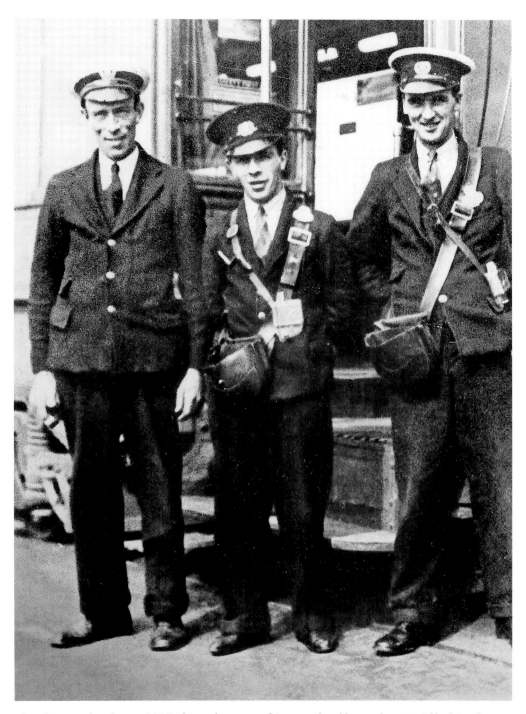

This photograph, taken in 1937, shows three tram drivers at the old tram depot in Gilford Road.
(Courtesy of Leo Sheeran)

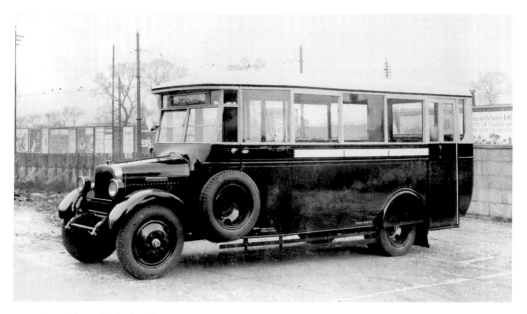

An old single-decker buses as used on the 52 route via Bath Avenue. (Courtesy of Michael Corcoran/National Transport Museum of Ireland, Howth)

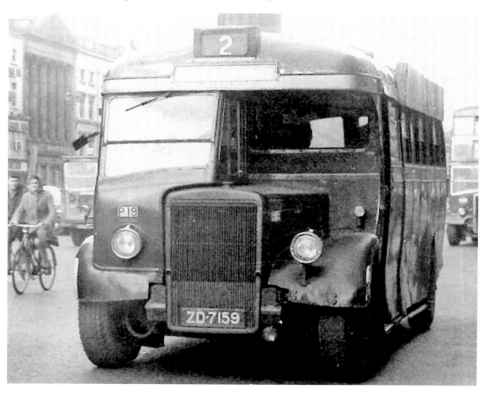

A single-decker buses on the 2 route.

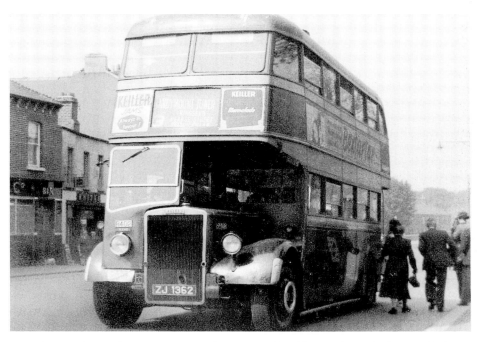

No. 3 bus on the Sandymount route in the 1950s. The old green buses had open platforms at the rear, which meant it was easy to hop on and off when the bus was stopped in traffic or at traffic lights. Buses had replaced trams on all the Sandymount routes by 1940. (Courtesy Michael Corcoran/National Transport Museum of Ireland, Howth)

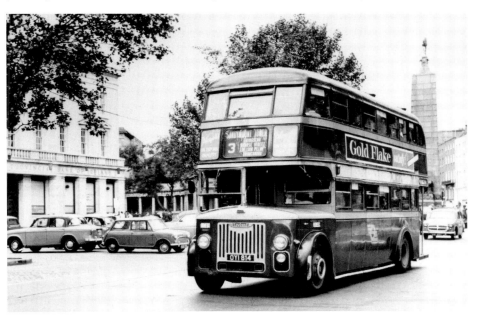

An old-fashioned green double-decker bus, used during the 1950s and 1960s on routes to and from Sandymount. (Michael Corcoran/National Transport Museum of Ireland, Howth)

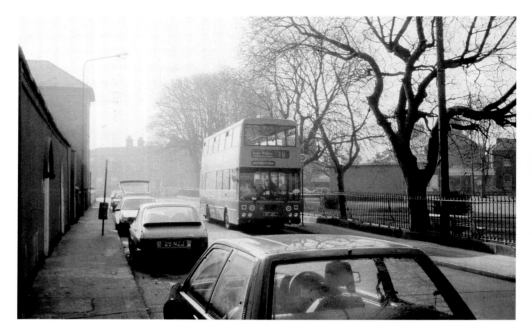

The No. 18 bus at the terminus beside Sandymount Green in the early 1970s.

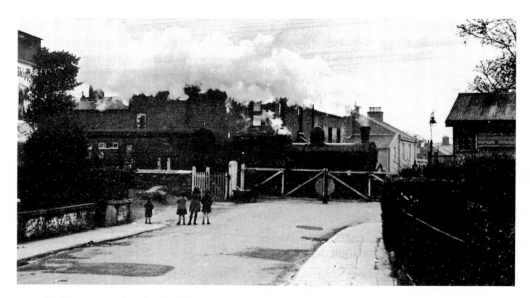

Children wait for the level-crossing gates at Serpentine Avenue to open. The train seen steaming past was on its way to Kingstown, now Dún Laoghaire; the name was changed in 1921. No date has been given for this photograph by the renowned photographer Fr Francis Browne, but it was probably just before the First World War. The land on the left-hand side of the photograph has now been developed into a small shopping centre, while many of the houses on the far side of the gates are still there. (Courtesy of *The Annals of Dublin, Fair City*, by E.E. O'Donnell, SJ)

D.U.T.C. TRAMWAY SERVICES

No.	Route	Symbol	No.	Route	Symbol
1	NELSON PILLAR - RINGSEND		16	WHITEHALL - TERENURE	✠
2	NELSON PR - SANDYMOUNT GN	◡	17	DRUMCONDRA - RATHFARNHAM	✠
3	NELSON PR - SANDYMOUNT TOWER	◡	18	KENILWORTH RD. - LANSDOWNE RD.	☐
4	NELSON PR - SANDYMOUNT VIA BATH AVE.	—	19	RIALTO - GLASNEVIN	◆
5	PHOENIX PARK NELSON PILLAR • PEMBROKE	—	20		
6	NELSON PILLAR - BLACKROCK	✿	21	INCHICORE - COLLEGE GN - WESTLAND RW	●
7	NELSON PR - DUN LAOGHAIRE	✿	22	KINGSBRIDGE - HATCH ST - RATHMINES	☐
8	NELSON PILLAR - DALKEY	✿	23	PARKGATE ST - BALLYBOUGH	◆◆
9	PHOENIX PARK - MERRION SQ - DONNYBROOK	◆◆	24	O'CONNELL BDS - PARKGATE ST	☐
10	PHOENIX PK: ST STEPHEN'S GN - DONNYBROOK	◆◆	25	O'CONNELL BDS - LUCAN	—
11	CLONSKEA - DRUMCONDRA	∞	26	O'CONNELL BDS - CHAPELIZOD	—
12	NELSON PR - PALMERSTON PARK	○	28	JAMES'S ST - ST LAWRENCE RD (LATER NELSON PR - FAIRVIEW)	
13	FAIRVIEW - WESTLAND ROW VIA ABBEY ST.	◪	29	NELSON PR - CASTLE AVENUE	
13			30	NELSON PR - DOLLYMOUNT (ST. LAWRENCE ROAD - 30A)	▼
14	NELSON PILLAR GLASNEVIN • DARTRY	⚠	31	NELSON PILLAR - HOWTH	
15	NELSON PR - TERENURE VIA RATHMINES	▲	—	COLLEGE GN - CAPEL ST - WHITEHALL	⌂

A noticeboard for the tramway services of the Dublin United Tramways. Sandymount was served by a number of tram routes, the Nos 2, 3 and 4, all of which started at Nelson's Pillar in what is now O'Connell Street. After 1918, each tram route was numbered, but before that, each one had a symbol to cater for the large number of passengers who were illiterate. No. 1 route went as far as Ringsend, while the No. 2 route terminated at Sandymount Green. No. 3 route went as far as the Tower on Strand Road, while the No. 4 route ran to Sandymount Tower via Bath Avenue, ducking under the low railway bridge at the top of Bath Avenue in the process. (From Irish Trams, courtesy of James Kilroy)

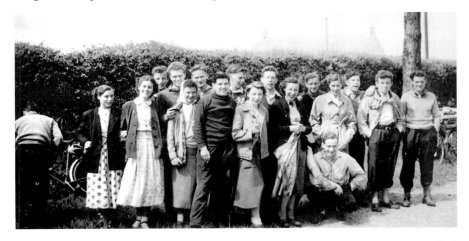

In 1950, bicycles were still the most common mode of transport, as few could afford a car. This photograph shows a group of people belonging to An Óige, the youth hostelling organisation, assembled in Irishtown for a spin. Their numbers included many from Sandymount. (Courtesy of Leo Sheeran)

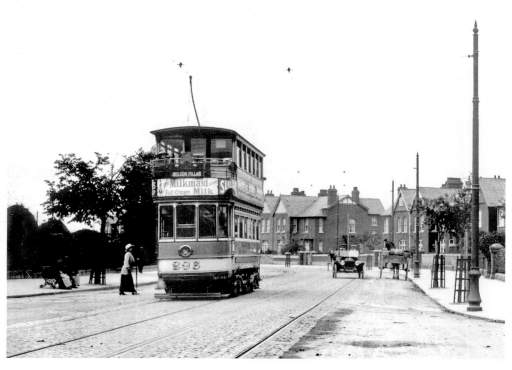

A tram on the Merrion Road, close to the top of Sandymount Avenue.

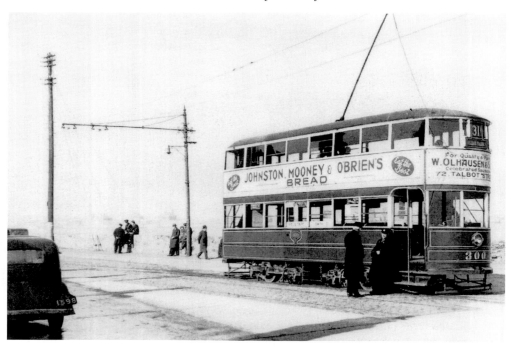

A tram on the seafront at Sandymount.

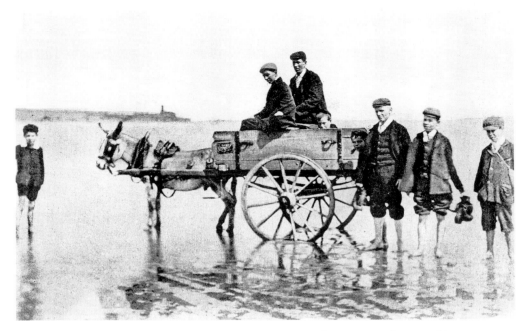

A horse-drawn cart on Sandymount strand; in years gone by, races on the strand between such vehicles were a popular pastime.

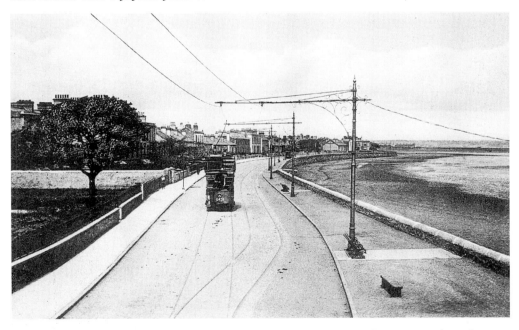

A tram going along Strand Road in the early years of the twentieth century, when the Martello Tower on Strand Road was a terminus for trams. The wide road is devoid of all other traffic and the poles supporting the overhead electric wires for the trams have a lattice-work visual effect on the road.

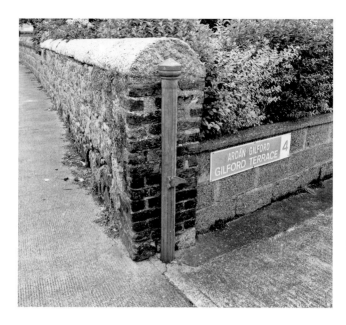

The name plate for Gilford Terrace, off Gilford Road. The houses were built for workers at the adjacent tram depot.

The old railway station at Sandymount, which had a chequered career. It opened in 1835 after the service began in 1834 from Westland Row to Kingstown, then closed in 1841, reopening in 1860. It closed again in 1862, until 1882, and then shut once more, in 1901. It reopened in 1928 – this is the station pictured here – and closed in 1960. It then reopened for just under three months in 1960, before closing again. It remained closed until the new DART station was opened in 1984. Sydney Parade station also opened in 1835; its modern reincarnation opened in 1972. Also in 1835 – but only for the months of January and February that year – Serpentine Avenue had its own station. The arrival of the railway in Sandymount in the mid-1830s played a big part in the development of the area. For the first time, people could live

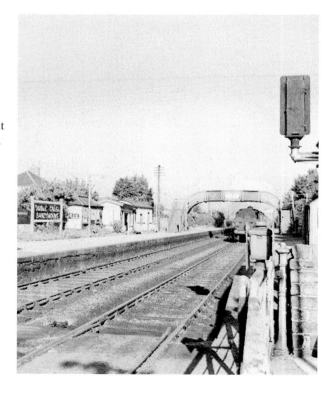

in Sandymount and easily commute into town and this encouraged the start of middle-class housing development in the district. (Courtesy of the O'Dea collection/National Library of Ireland)

6

CHURCHES AND
EDUCATION

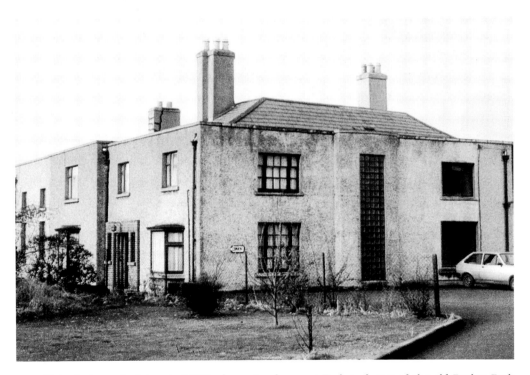

This photograph, taken in 1981, shows Sandymount Park and part of the old Roslyn Park School, not long before its closure. The Sisters of the Sacred Heart of Mary had started the secondary school for girls in 1950 and it closed in 1982. Subsequently, the buildings at Sandymount Park were taken over by Rehab, which opened its headquarters here in 1983. Rehab itself has been the source of much controversy.

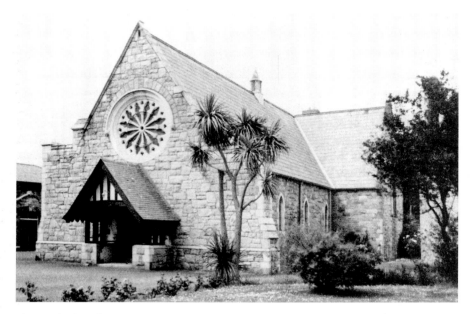

The Methodist church just off the Green was one result of the mid-nineteenth century church-building boom in Sandymount, just as the area was being developed on an extensive basis, for the first time. The church, designed by Alfred G. Jones in a Gothic revival style, was built in 1864. Its most prominent feature is the large rose window over the entrance. The entrance porch was added in 1911, designed by George G. Beckett, a member of the family of Samuel Beckett, the playwright. In 1975, it became Christ Church, Sandymount, when the local Methodist and Presbyterian congregations combined in a single church.

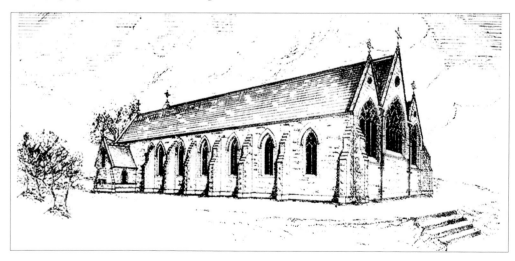

When the Star of the Sea church was designed by J.J. McCarthy, one of the great Victorian architects responsible for the Gothic Revival style, he envisaged a tower topped by a spire at the south-west corner of the church. The designs were completed in 1858, seen here, but the tower and spire were never built.

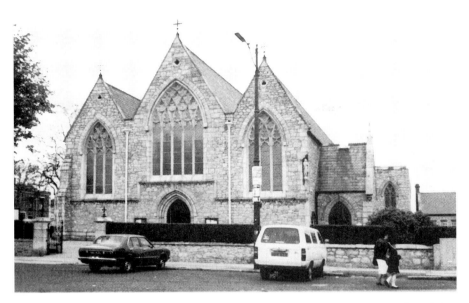

The Star of the Sea church was extended in 1889-91 to designs by W.H. Beardwood, but since then, the external structure, as seen below, has remained unchanged.

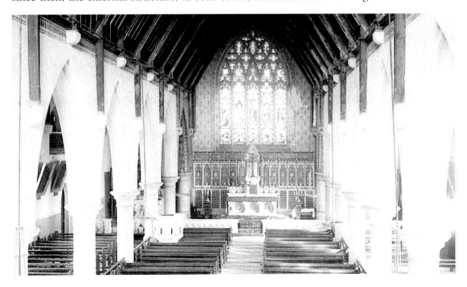

The Star of the Sea church interior, photographed during the 1890s. The interior has a nave and two aisles, all of equal width, matching the three external gables on the front façade. The pulpit and altar rail were made in 1880 by James Pearse, the sculptor father of Padráig Pearse, in memory of a former parish priest, Fr Leahy. A mural tablet was dedicated to Fr Leahy, while a bust as put up to commemorate a subsequent parish priest, Canon O'Hanlon. The interior of the church was extensively refurbished in the early years of this century, although the fundamentals of the design remain. In 2001, two parochial houses in the adjoining Leahy's Terrace had been sold off to pay for the renovations. (Courtesy of Lawrence collection/National Library of Ireland)

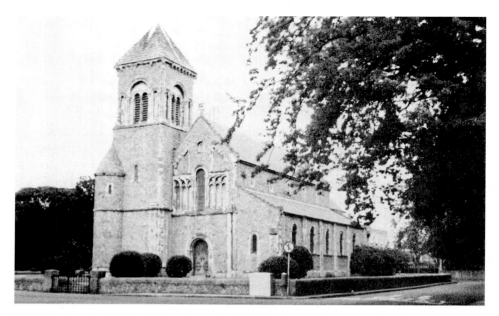

St John's Church of Ireland church, on the 'island' where Park Avenue meets St John's Road, was designed in 1850 by Benjamin Ferrey to replicate the style of early churches in Normandy. Its design was unique in Dublin. Ferrey had also intended to have sculpted beasts on the church exterior, but the then Anglican Archbishop of Dublin put his foot down and prevented them being used. However, one escaped; there is a dragon curled around a chimney on the roof at the rear of the church. The façade of the church was built with Bath stone, which has eroded severely in places.

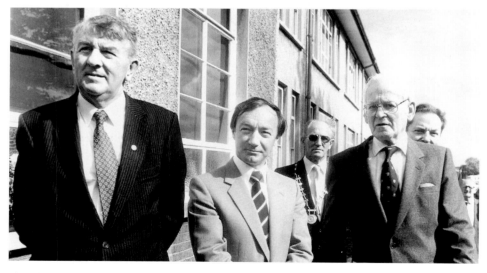

The official opening of the Rehabilitation Institute's headquarters at Roslyn Park in Sandymount in November, 1983. Pictured, from left, are Frank Cahill, the first chief executive of the Rehabilitation Institute Henry Murdoch and John McDowell, the first chairman. (Courtesy of Frank Fennell Photography)

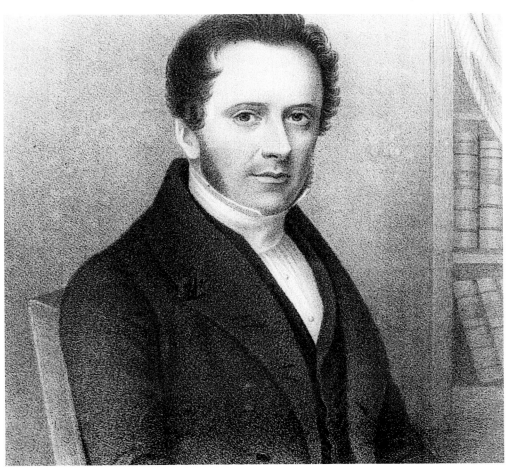

Revd William de Burgh, who was born at Oldtown, near Naas, County Kildare, in 1801, was one of the first rectors of St John's Church of Ireland church in Sandymount. After becoming a Doctor of Divinity at Trinity College, Dublin, he became rector of Ardboe, County Tyrone, before moving back to Dublin and St John's. He married his first wife, Anne Coppinger, in 1826; they had no children. After she died in 1850, the rector promptly remarried, to Jane McCartney, who went on to bear him an incredible number of children – 18 in all. Revd de Burgh died in 1866, presumably from exhaustion, and was buried at Mount Jerome cemetery in Dublin. (Courtesy of the National Library of Ireland)

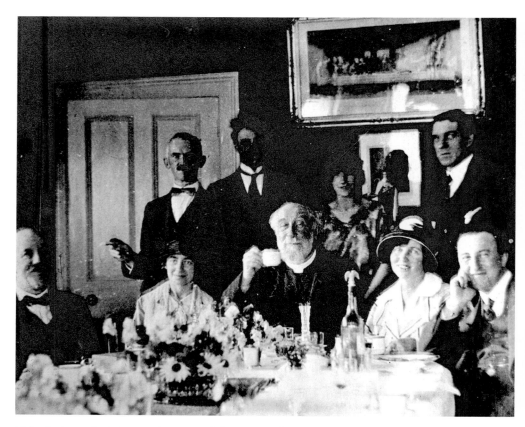

This photograph, taken at the start of the twentieth century, shows members of the choir at the Star of the Sea with the then parish priest, Canon O'Hanlon. He had been born in Stradbally, then Queen's County, now County Laois, in 1821 but after studying briefly for the priesthood in Carlow, he and his family emigrated to America. He was ordained in St Louis, Missouri, in 1848. Poor health forced him to return to Ireland 5 years later. In due course, after his health had improved, he was appointed to the Star of the Sea in 1880 and remained there until his death in 1905. (Courtesy of Brian Siggins)

The old national school at the end of what is now Sandymount Road, demolished in the late nineteenth century to make way for what became the Canon O'Hanlon memorial school. Another, later, school in Sandymount was the High School in Herbert Road, a co-educational secondary school owned by the Cannon family, which was established in 1947. In response, the then Catholic Archbishop of Dublin, John Charles McQuaid, encouraged Marian College to set up next door. The High School operated until 1999; the site now contains a gated housing development. (Courtesy of Brian Siggins)

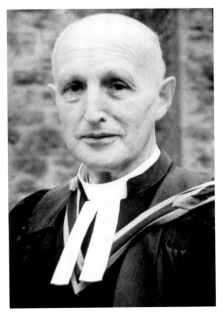

Revd John Scott Crockett, who was the Minister of the Presbyterian church at the foot of Tritonville Road, from 1917 to 1952. The first had been Thomas Lyttle, ordained there in 1855. During his time in Sandymount, the church was opened in 1858 and the manse and lecture hall were built, as well as a Presbyterian college. As for Revd Crockett, a native of Carrigans in east County Donegal, he was an outstanding figure in both the church and the community. In his time, he was considered the tallest man in Dublin. He was also the Clerk of the Presbyterian Church in Dublin for many years and his daughter Mary became a missionary in China. Revd Crockett died on 11 November 1958. The congregations of the Presbyterian church in Sandymount and the Methodist church there merged in 1975 and began using the latter church, renamed Christ Church, Sandymount.

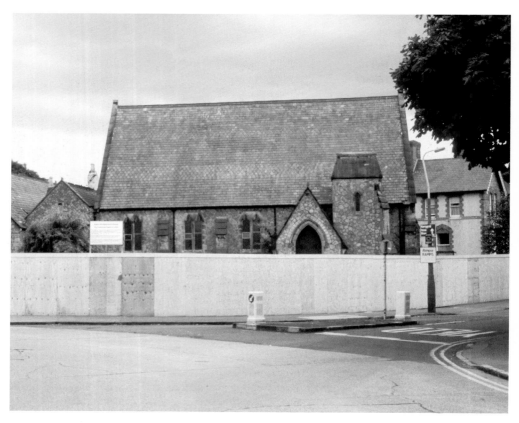

The old Presbyterian church at the end of Tritonville Road, in 1999, prior to its demolition that year. The church had been built in 1857/8 and was an architectural addition to Sandymount for many years. It had been unused for twenty years prior to its demolition. A total of 4,000 people signed a petition against its demolition, local people picketed the church and the then Heritage Minister, Síle de Valera, begged the Presbyterian Church authorities to defer the demolition, all to no avail. After the church was pulled down, in September 1999, the site was used for modern residential units, including sheltered accommodation. Other sheltered accommodation in Sandymount for elderly people includes Margaretholme, the Methodist residence in Claremont Road, and the Brabazon home in Gilford Road.

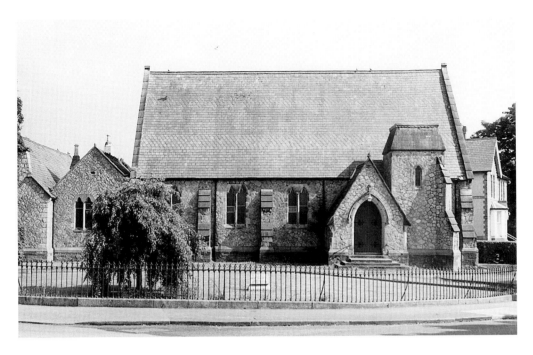

Above and below: The old Presbyterian church at the corner of Sandymount Road and Tritonville Road, before its demolition in 1999 and as the old convent was being demolition, when the church was cleared to make way for apartments and also sheltered housing for the elderly.

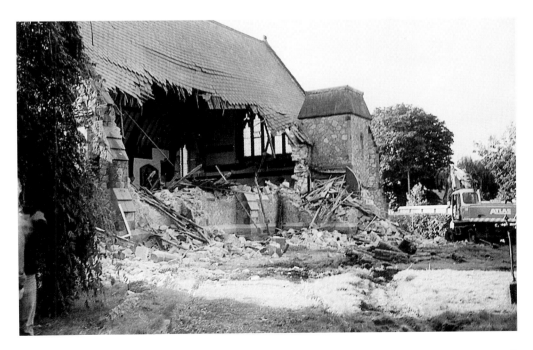

The old and new chapels at Lakelands convent in Gilford Road, seen about twenty-five years ago, just before the old convent was demolished. (Courtesy of Brian Siggins)

The old Lakelands convent. The Sisters of Charity ran the convent here, where they also had an industrial school and an orphanage. The industrial school remained in use until about twenty years ago; by the late 1970s, girls from that school moved into new accommodation in Park Avenue. For many years, the Sisters also ran a primary school at Lakelands, and this was subsequently used as a vocational school between 1975 and 1980. The new girls' national school, Scoil Mhuire, opened in 1974. In the late 1970s, the old convent, seen here, was demolished and the new convent opened in 1979. (Courtesy of Leo Sheeran)

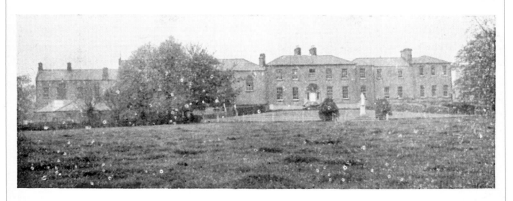

Lakelands

The old Lakelands convent at Gilford Road.

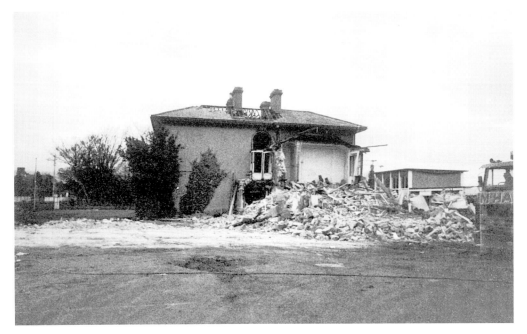

The house on Sandymount Avenue that was once the family home of Mother Mary Martin became the headquarters of the national cerebral palsy association founded by Dr Robert Collis in 1948. In the late 1990s, the house was demolished and the present Enable Ireland headquarters were built on the site. (Courtesy of Anthony J. Jordan)

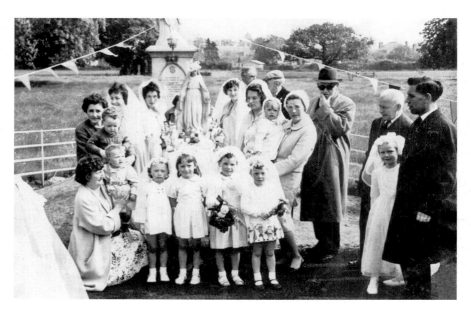

A group of local people seen taking part in the May procession at the Lakelands convent in Gilford Road in 1962. Among those taking part were Maureen Siggins (left) holding her infant son Gerard, who is now a well-known sports journalist. Her husband and his father is Brian Siggins, the well-known local historian. At the rear right, wearing a hat, is Frank Dalton. His wife, Eileen, is in front of him, holding their infant son, John. Also in the photograph, front row, second right, is the Daltons' daughter, Enda and far right, front row, another daughter, Paula. On the far left is Elizabeth Reeves and to her right, Evelyn Reeves. (Courtesy Caritas/ Irish Sisters of Charity)

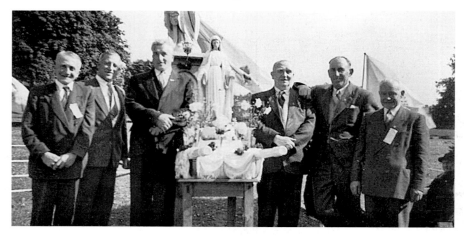

Gardaí from the Irishtown station at the May procession in Lakelands convent, Sandymount, 1960. These days, such mandatory attendance has passed into history. The Gardaí seen here were based in the old Garda barracks, directly opposite the new one, which was opened in 2008. The old barracks originally formed the rectory for the nearby St Matthew's church; the building was converted to a police station, covering Ringsend, Irishtown and Sandymount in the 1970s. (Courtesy of Caritas/Irish Sisters of Charity)

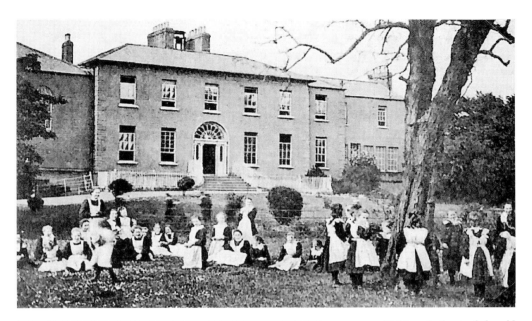

Children in front of the old Lakelands convent, where the old primary school was based, *c.* 1900. The convent also included an industrial school, started in 1866, and closed approximately 20 years ago.

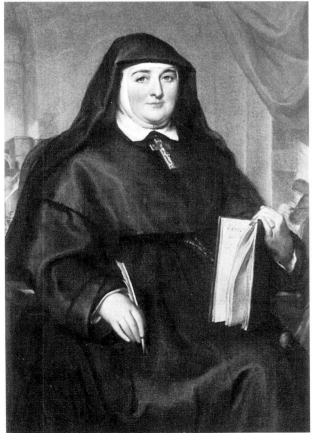

Mother Mary Aikenhead, founder of the Sisters of Charity in the early 1830s. In 1831, she and four other sisters had moved into a small house on Sandymount Lane, now Sandymount Avenue, where they ran a poor school. Later on, a community of Carmelite Sisters from North William Street moved into Lakelands in Gilford Road. The two communities swapped places in 1876; the Carmelites went to live on Sandymount Avenue while the Sisters of Charity took over Lakelands. (Courtesy Caritas/ Irish Sisters of Charity)

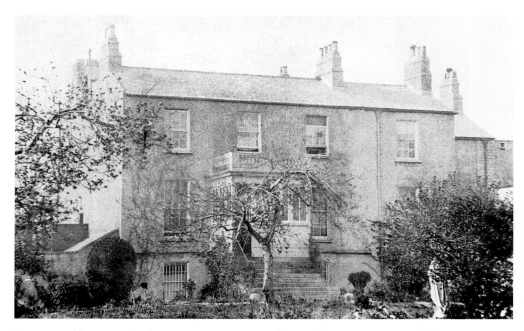

The original house in Sandymount Avenue occupied by Mother Mary Martin and her Sisters of Charity.

Part of the old Lakelands convent before it was demolished and rebuilt about twenty years ago. The old convent also had an industrial school and a primary school; Scoil Mhuire, a girls' national school, opened in 1974, before the present day convent was built.

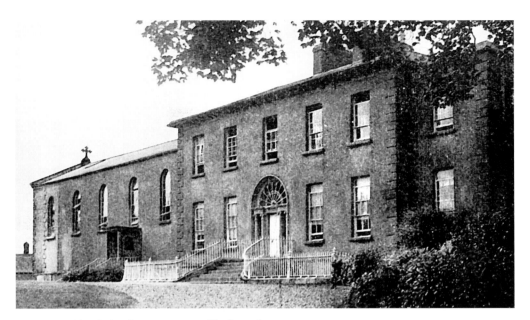

The old Lakelands convent at Gilford Road.

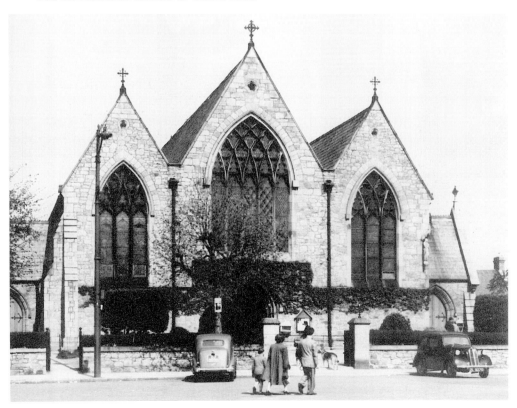

An old photograph of the façade of the Star of the Sea church.

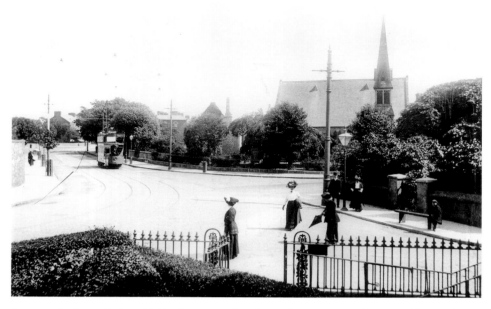

A general view of the old Presbyterian church at the junction of Tritonville Road and Sandymount Road. The building was demolished in 1999. (Courtesy of Lawrence Collection/ National Library of Ireland)

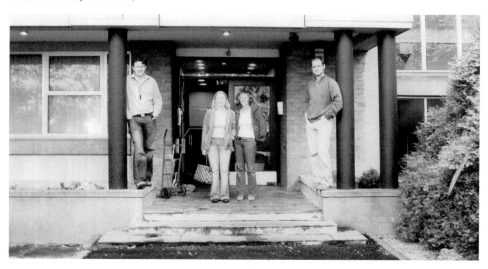

For many years, the headquarters of Teagasc, the agricultural research organisation, was in Sandymount Avenue. The photograph shows staff on the front steps on their last day in Sandymount, in 2004. From left to right: Trevor Donnellan, Fiona Thorne, Thia Hennessy and Kevin Hanrahan. They were all economists with Teasgasc's rural economy programme. The buildings were subsequently demolished and the Shrewsbury Square luxury apartment complex developed on the site. (Courtesy of Teagasc)

7

LOCAL
BUSINESSES

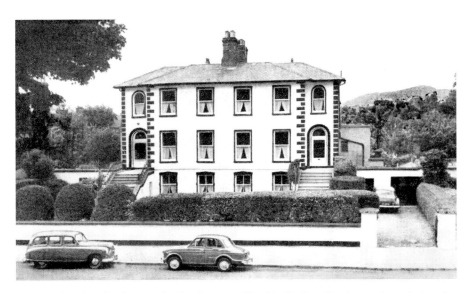

The only hotel in the district, the Sandymount Hotel in Herbert Road, seen here during the 1950s during its previous incarnation as the Mount Herbert Hotel. It was founded by the Loughran family in 1955 and today it is run by the second and third generations of that family. For many years, it was known as the biggest B&B in Ireland, with as many as 100 bedrooms, but since its name was changed in 2011, many upgrades have been carried out. Mary Kenny,the well-known writer and journalist,grew up in No 3, Herbert Road,which was subsumed into the hotel. She remembers that in those days on the hotel side of the road men were called 'Esquire' while on the opposite side,they were plain 'Mr'. (Courtesy of Sandymount Hotel)

Findlater's shop was a fixture at No. 2 The Green, from 1897 until its closure in 1969. It sold a wide range of groceries and wines and was noted for its personal service. Customers placed their orders at the counter and when the bill was made up, it and the cash were sent on a pulley-like overhead contraption to the cashier's desk in the centre of the shop. Customers could also get their orders delivered by bicycle. In the early 1960s, the shop in Sandymount was modernised and Findlater's got a new style-front window, but it was too late. H. Williams supermarket, now Tesco, arrived in Sandymount in 1966. What was Findlater's shop is now Mario's restaurant, one of the best-known places to eat out in Sandymount, along with other establishments, such as Dunne & Crescenzi in Seafort Avenue. Further along the north side of Sandymount Green is Browne's Brasserie, opened in 2013 as an offshoot of Brown's café and deli directly across the Green. It's now known as Pete's. The north side of the Green has also had Borza's fish and chip shop for more than 30 years. (Courtesy of Alex Findlater)

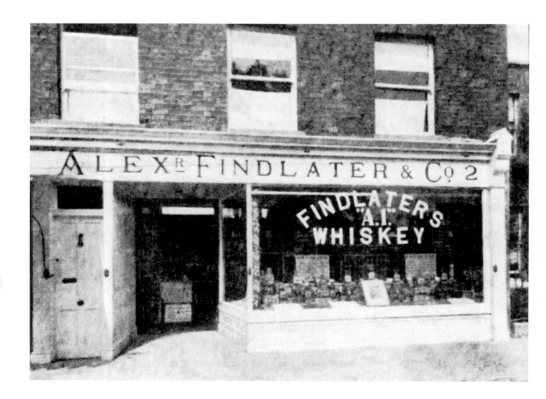

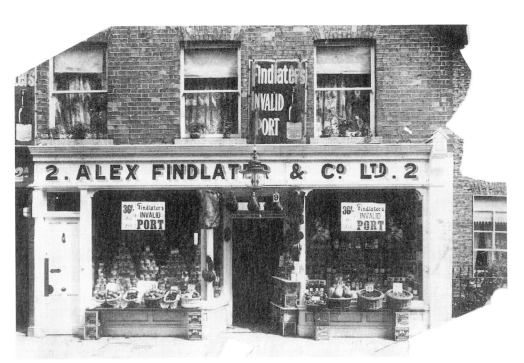

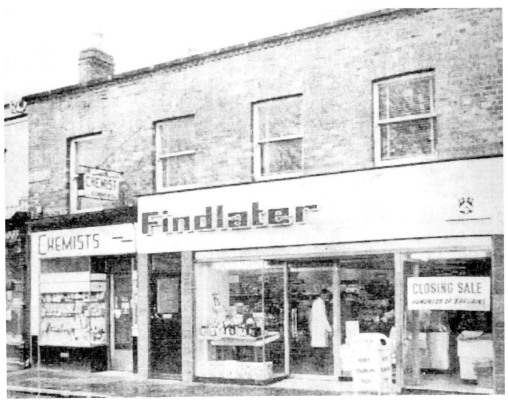

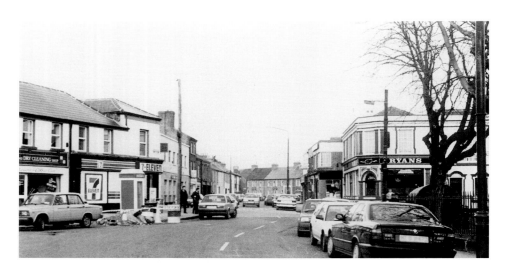

The Claremont Road side of Sandymount Green, seen in the 1970s, with the 7-Eleven supermarket on the corner (now Spar) and cars parked beside the footpath that runs around the Green. (Courtesy of Lorna Kelly)

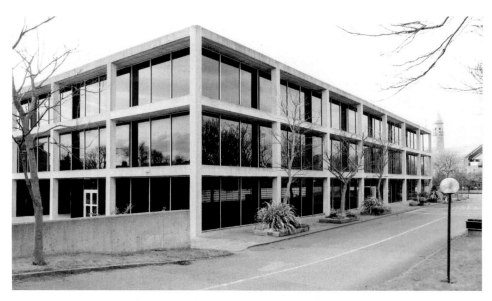

Merrion Hall on Strand Road was opened in 1973, after being constructed despite many concerns that the land on which it was built was liable to flooding. The modernistic design has stood the test of time. Irish Shipping, the State-owned shipping line, was based there until it was shut down in 1984. For many years, it was also the headquarters of Coras Tráchtála, the export board, which was closed down in 1998. Subsequently, it was occupied by Enterprise Ireland before it moved to its present headquarters at East Point business park. Today, it is occupied by a number of commercial concerns, including the Outsource Services Group. The hall was built on the site of riding stables once owned by the Fallon family, who exercised their horses on the strand, just the other side of Strand Road. (Courtesy of Enterprise Ireland)

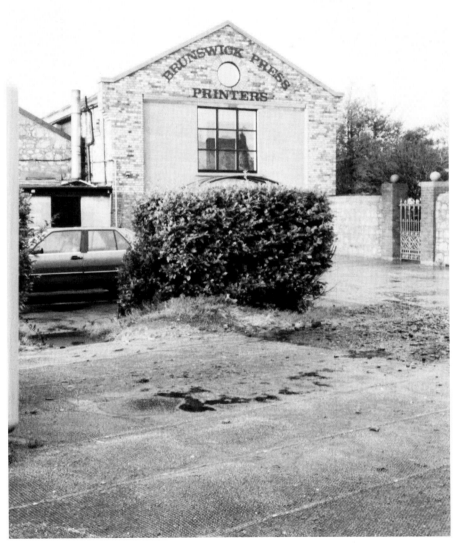

Part of the old tram depot in Gilford Road, which now houses the Irish International advertising agency. This building also housed the Brunswick Press for many years; the firm was the official printer to the University of Dublin, better known as Trinity College. The firm had been founded in 1734. About fifteen years ago, it moved out of Sandymount and relocated to the Bluebell district of Dublin, but sadly went into liquidation during 2015. (Courtesy of Irish International)

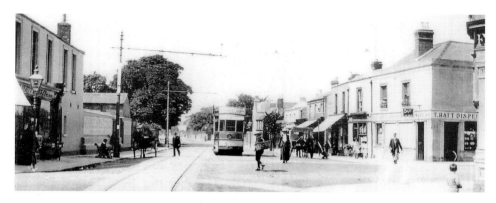

A tram seen approaching Sandymount Green from the Seafort Avenue direction, about 100 years ago. On the right-hand side can be seen what is now Ryan's pub, while on the left-hand side is what is now the Spar supermarket. Ryan's pub in Sandymount village dates back to 1899. It has been owned by the Ryan family since the late 1970s. O'Reilly's pub, which used to be White's, in Seafort Avenue, older than Ryan's, going back over 170 years. In the old days, Sandymount had five pubs, two more than today. (Courtesy of Leo Sheeran)

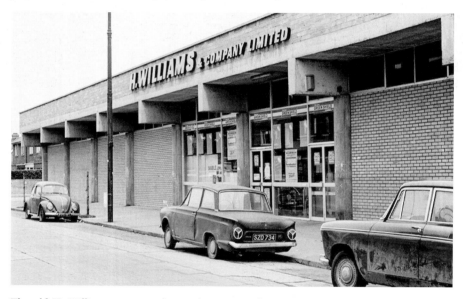

The old H. Williams supermarket at the corner of Sandymount Road and Marine Drive. It was built in 1966, when the company was undergoing rapid expansion in the then new supermarket business. It was constructed on the site of the old National Vaccine Institute, which had been established in 1896 to produce supplies of vaccinia, the variation of cowpox, which is used to produce immunity to smallpox. Dr John Knox Denham, the Master of the Rotunda, in all probability provided the funds for its purchase. His son, Dr John Denham, was the dispensary doctor in Ballsbridge and his son, Dr Charles Holmes Denham, ran the Vaccine Institute for most of his career. It continued until the 1950s, when the government began to source vaccines abroad. H. Williams went out of business in 1986, following a supermarket price war, and the Sandymount branch became first a Quinnsworth outlet and then, in 1997, a Tesco. (Courtesy of RTÉ Archives)

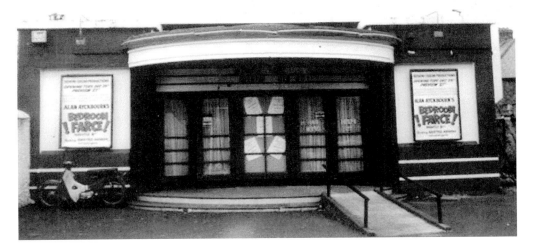

Known popularly as 'The Shack', the old Ritz cinema started off in 1936 as the Astoria, then became the Ritz and finally, the Oscar. When it was a cinema, it could seat 700 patrons and unusually for that era, had regular Sunday screenings, while the programme was changed three times a week. It survived as a cinema until the mid-1970s, when it was converted into a theatre. Theatrical productions there were many and varied, ranging from the world premiere of the play based on the autobiography of Christy Brown to one of the first all-nude productions seen on the Dublin stage. But by the mid-1980s, it had ceased to be financially viable. In December 1986, it was bought by the Sikh community in Ireland, which then numbered fewer than 100, to be used as their central religious and cultural headquarters in Ireland. (Courtesy of Stephen Harte, www.pintrest.com)

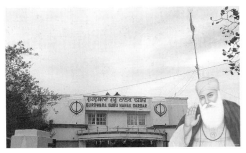

The Sikh temple and cultural centre in the converted cinema. (Courtesy of Ramanjit Singh Lamba, Gurdwara Guru Nanak Darbar, Serpentine Avenue, Sandymount)

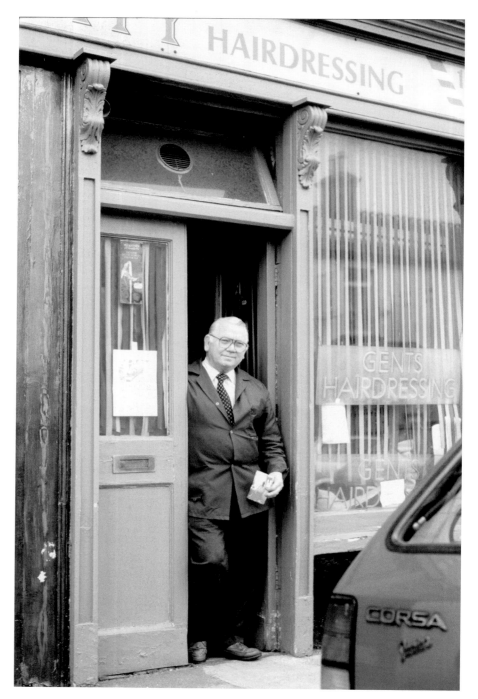

The old barber's shop in Seafort Avenue, with owner John Duffy standing in the doorway. The premises was a couple of doors along Seafort Avenue from Brian O'Brien's Books on the Green bookshop. The old barber's shop was at No. 10, beside the old dairy. (Courtesy of Brian Siggins)

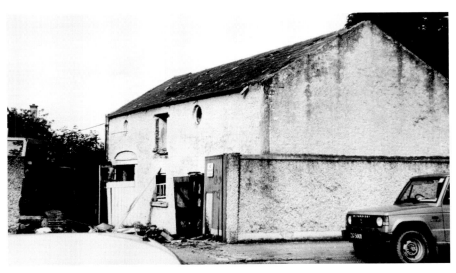

The old farmhouse that once stood close to the Star of the Sea church. Sandymount Road was then little more than a country lane and it was common to see cattle in that lane. In those days, local butcher's shops, such as Hayden's in Claremont Road, had their own abattoirs. The farmhouse was demolished to make way for St James's Terrace on Sandymount Road. (Courtesy of Brian Siggins)

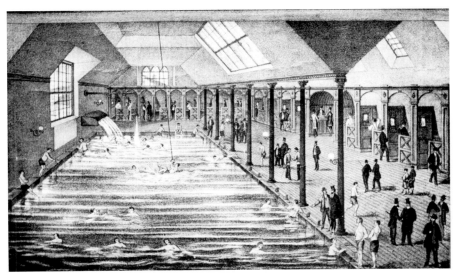

Around 150 years ago, the Cranfield Baths were a busy place, close by the Star of the Sea church and the strand. Founded in the 1790s, these large-scale indoor baths were very fashionable and they offered both hot and cold baths, using water from the incoming tide. The baths were such a big attraction that they brought many people to stay in Sandymount, lodging with nearby families. By the 1820s, Sandymount, with its fresh air and wide views over the bay, had become a popular tourist resort for residents of Dublin city. The baths survived until 1890. The outdoor seawater baths on Sandymount Strand had opened in 1883.

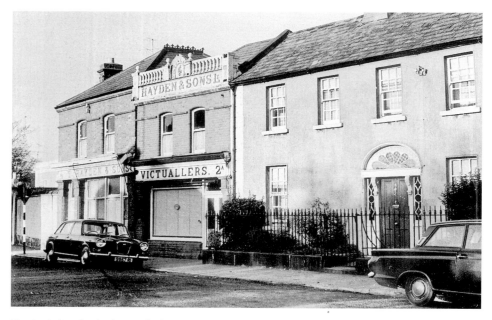

Hayden's butcher's shop, which stood at the foot of Claremont Road, with its adjoining house. For many years, Hayden's was a popular shop in Sandymount, but thirty years ago, the shop and the adjoining properties were demolished to make way for offices for the Revenue Commissioners, as well as a modern terrace of houses. One of the houses in the original terrace, No. 18, was occupied by Éamon de Valera, when he was a young teacher, a decade before the events of 1916 propelled him to political fame. The woman he married in 1910, Sinéad Ní Fhlannagáin, also a teacher, also lived for a while in Sandymount before their marriage. (Courtesy of Lorna Kelly)

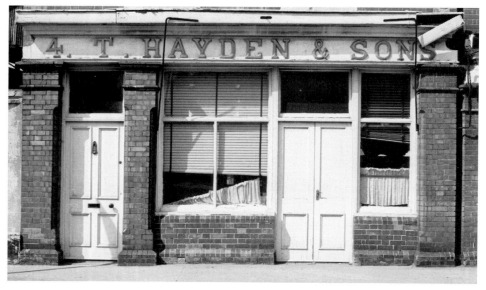

Part of Hayden's old shop, after it closed and before it was demolished. (Courtesy of Tom Kennedy)

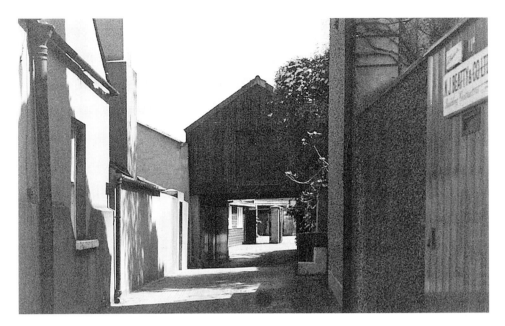

Beatty's Yard, off Claremont Road; it's on the left-hand side going towards Serpentine Avenue. This photograph shows it as a traditional builder's yard, as it was for many years. Today, it is still there, but totally changed, as it has been refurbished to provide a number of professional offices. (Courtesy of Lorna Kelly)

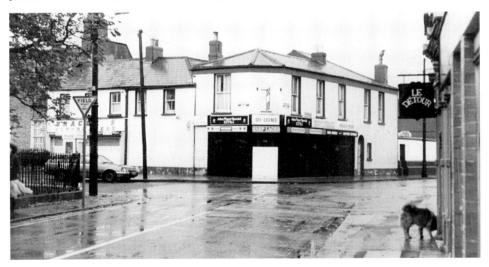

This photograph shows Bracken's supermarket, at the corner of Claremont Road and Sandymount Road, where the present-day Spar supermarket stands. After the upmarket Leverett & Frye grocery shop closed here, in 1967, the Bracken family eventually took over the premises. At first, they paid £2,400 for a small shoe repair shop next door, which formed their first shop. When Leverett & Frye closed, they paid just over £10,000 to make their own supermarket. Bracken's closed in 1985. On the right of this photograph, taken in the early 1970s, is Le Détour, one of Sandymount's first exotic restaurants. (Courtesy of Lorna Kelly)

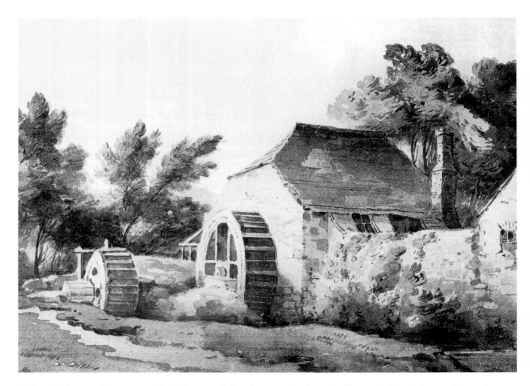

This old flour mill was on the fringes of Sandymount, close to Beggar's Bush barracks and the present-day Lansdowne Road, near where Herbert Road is now situated. It was on one of the many watercourses that then flowed from the River Dodder. The mill, which was in delightfully rural surroundings, probably didn't survive beyond about 1840, while an even bigger undertaking in the Herbert Road area, Haig's Distillery, had closed down in 1833. This watercolour painting of the mill by Francis Danby was created in 1813 and is now in the Ulster Museum, Belfast. (Courtesy of Brian Siggins)

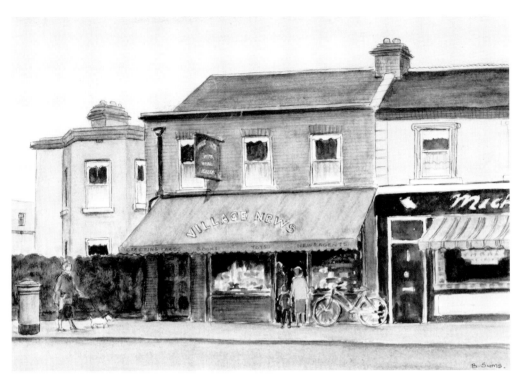

The old Village News shop and post office on Sandymount Road, which closed down in 2002, when owner Vincent Tierney decided to retire. He and his wife had run the shop for about fifteen years. This painting of the shop is by Barbara Syms, a Dublin-based artist. Other noted shops on that part of Sandymount Road included Strecker's the pork butchers, founded in 1927 by Carl Strecker when he arrived from Germany. He died after falling from his horse while out riding on Bray Head. The Monument Creameries shop was also popular for its fresh produce and bakery items long before refrigeration came into use; it closed down in 1966. The Village News shop has been replaced by modern buildings, including a pub and a restaurant, but beside it, Michael Byrne's butcher's shop is still going strong. Michael took over the shop in 1980, having worked in it for the previous nineteen years. (Courtesy of Vincent Tierney)

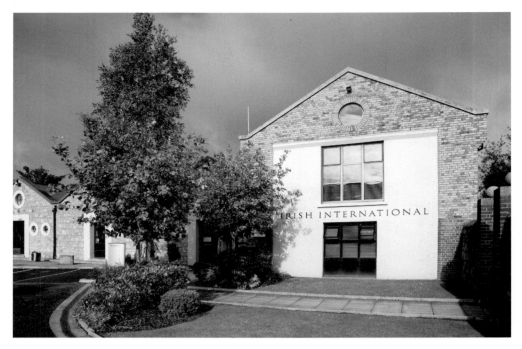

Part of the old tramway depot at Gilford Road, which in the late 1980s was transformed into the offices of the Irish International advertising agency. It was established in 1966 and since has become one of the leading advertising agencies in Dublin, renowned for its creative skills. The agency moved to Gilford Road in 1998 and its premises have been substantially upgraded since then. (Courtesy of Leo Sheeran and Irish International)

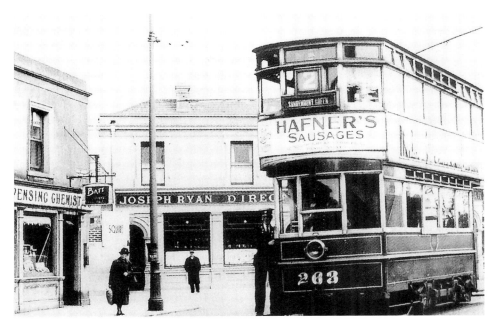

A No. 2 tram heading down Sandymount Road from Sandymount Green. On the left-hand side is Batt's the chemists, founded in 1875. Thomas Batt ran it for many years until his son Charlie took over; when Charlie retired from the business around forty-five years ago, he pursued a new career, playing piano on cruise ships sailing the oceans of the world. The building was sold to AIB, which in the 1970s demolished it and built the present bank branch at the corner of Seafort Avenue and Sandymount Road. Michael McAuliffe started his career with Batt's in 1963, working with Charlie Batt and his daughter, Denise. Michael's father Philip had come to Sandymount in the 1920s to manage Roche's chemists and in the late 1930s he bought it, running it under his own name. Michael McAuliffe ran the shop from 1964 until he retired and sold the business in 2000. (Courtesy of Leo Sheeran)

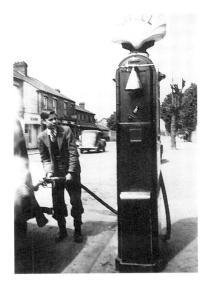

This old Shell petrol pump stood outside the garage at No. 86 Sandymount Road for many years; this photograph was taken in the 1950s. The garage was originally owned by Paddy Reynolds, but was then taken over by Ray Jackson. The site of the old garage is now occupied by Mulligan's pub. These days in Sandymount, 4×4s and SUVs are just as likely to be seen as saloon cars. (Courtesy of Ray Sheeran)

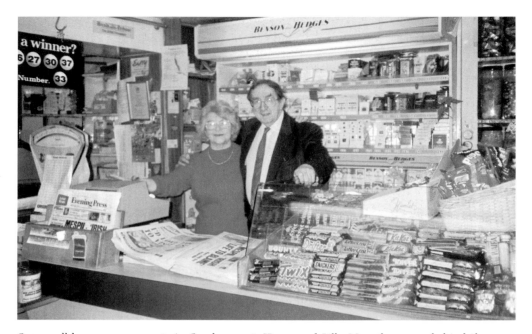

Once well-known newsagents in Sandymount, Harry and Lilly Mapother, seen behind the counter in their shop on Sandymount Green, which closed in early 1999 when they retired. The shop and living accommodation above was sold later that year and the site now forms the premises of a local art gallery with the auction rooms of Bennett's occupying the overhead space. (Courtesy of Delia Aherne)

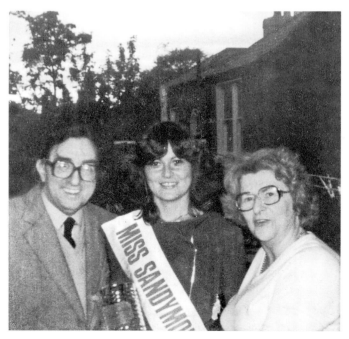

Delia Aherne worked with the Mapothers in their Sandymount Green shop for many years and she is seen here with Harry and Lilly Mapother. Harry died six months after the shop closed while Lilly died eight years later. (Courtesy of Delia Aherne)

Tom McCormack is seen closing up his greengrocers in Sandymount for the last time, back in 1994. The shop is now Books on the Green. Tom had run his shop for over thirty-five years and for many Sandymount residents, it was their first stop for fresh fruit and vegetables. In 1968, he introduced another innovation: chicken roasting in the front window, which drew many shoppers. Tom, who came from Baileborough, County Cavan, had served his time with a small grocer's shop on Sandymount Road, McQuaid's, which was close to where he eventually set up his own shop. After McQuaid's, Tom went to work for Leverett & Frye (now the Spar supermarket) before starting on his own. He died in July 2015. (Courtesy of News Four)

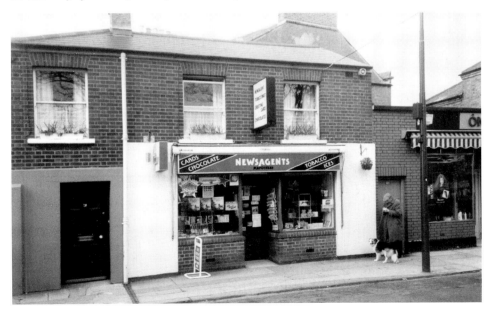

The exterior of Mapother's old newsagents shop on Sandymount Green. (Courtesy of Delia Aherne)

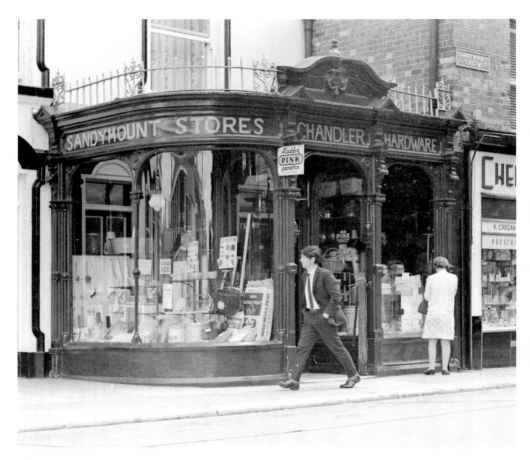

Sandymount Hardware Stores on Sandymount Green in the 1970s. The stores, established 150 years ago, were run for many years by Miss Milligan, from Cork, who always wore her white hair in a bun. The hardware shop always stank of paraffin and the wooden floors creaked. Transactions were rung up on the big old metal cash register. The old curved glass window was broken during repair work in the 1980s and had to be replaced with perspex. These days the shop is Murphy's pharmacy. Nearby was Miss Roddy's grocery and sweet shop, with glass jars packed with childish temptations. (Courtesy of Tom Kennedy)

8

SPORTS AND
RECREATION

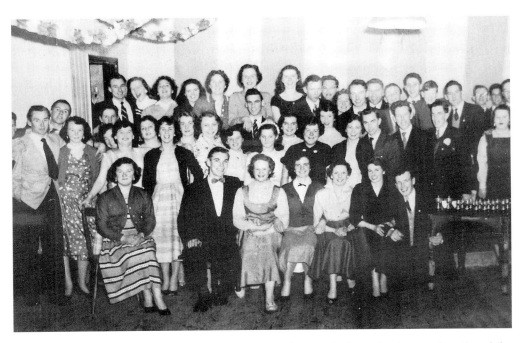

This photograph shows a group of young people, mainly from Sandymount, gathered for a dance at the Ancient Order of Hibernians' hall at the corner of Tritonville Road and Newbridge Avenue in the late 1950s. Leo Sheeran, from Sandymount, says that all his sisters are in the photograph, as well as his brother, Martin, seen here as the teenager with the bowtie in the front row. The tall man on the left of the photograph is the Sheeran family's father, Joseph. Today, the site of the AOH hall is occupied by the Iris Charles Centre for Elderly People, founded in 1960. (Courtesy of Leo Sheeran)

A group working on the Sandymount community parade thirty years ago. They include, from left, Berna O'Gorman, Maeve Corcoran, Anne O'Rourke, Bernie O'Shea, Philomena Fyffe, Madeleine O'Keeffe, Mary Kelly and Michael McAuliffe. (Courtesy of Michael McAuliffe)

A Tidy Towns working committee in Sandymount making the preparations for the district's entry in the competition in the mid-1980s. From left to right: Bernadette Cassidy, manager, First National Building Society branch, Sandymount Road; Berna O'Gorman; Margaret O'Doherty; Pauline Smith with her son Dermot; Madeleine O'Keeffe; Michael McAuliffe and Paddy Kavanagh. (Courtesy Michael McAuliffe)

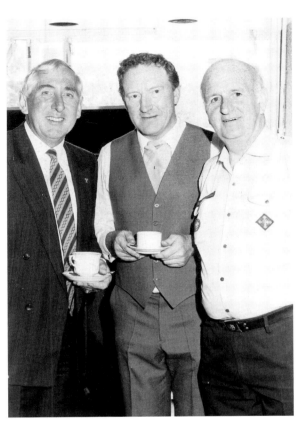

From left to right: Ronnie Delany, Michael McAuliffe and Frank Geoghegan, a local scoutmaster, seen about thirty years ago. (Courtesy of Michael McAuliffe)

An unusual Bloomsday gathering, in the front garden of the home of Michael and Rosa McAuliffe on Sandymount Road, in 2005. (Courtesy of Michael McAuliffe)

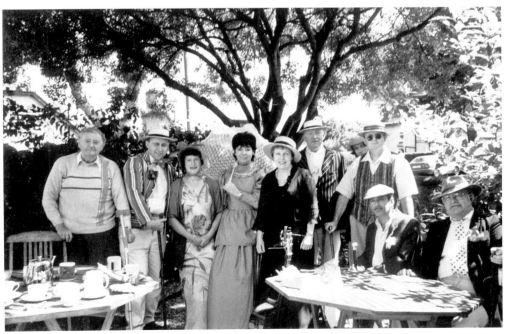

Michael McAuliffe with a well-known Bloomsday character in Sandymount, Michael Lynsky, who has made a career out of being a reincarnation of James Joyce. Rodney Devitt, who lives in Sandymount, is considered the area's expert on James Joyce and his multifarious works.
(Courtesy of Michael McAuliffe)

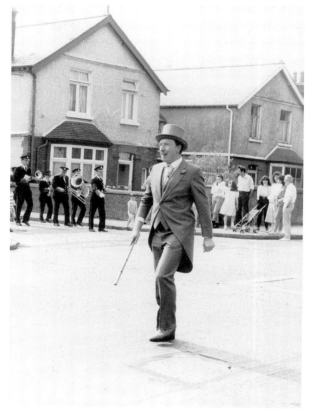

Michael McAuliffe striding out along Sandymount Road, during a Community Week event in 1985. He was the Master of Ceremonies and he is seen passing the McAuliffe house at the corner of Farney Park and Sandymount Road.
(Courtesy of Michael McAuliffe)

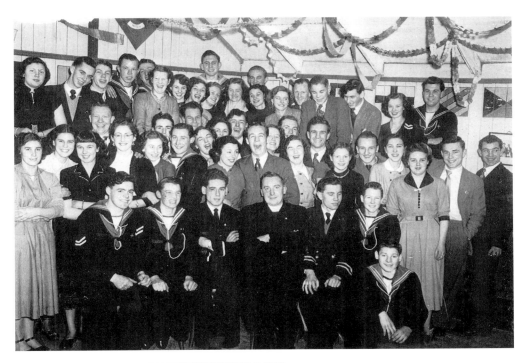

A dance held at the Sea Scouts' hall in Irishtown during the 1950s. Many of the people in the photograph were from Sandymount. (Courtesy of Leo Sheeran)

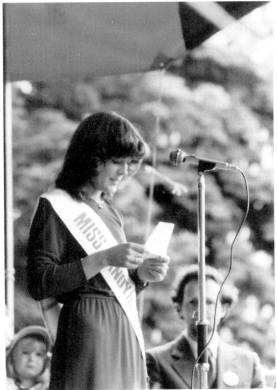

The winner of the first Miss Sandymount competition, Delia Aherne, during the inaugural community week in Sandymount in 1982. She is seen here making her acceptance speech after winning the prize. Delia still lives in Sandymount. (Courtesy of Delia Aherne)

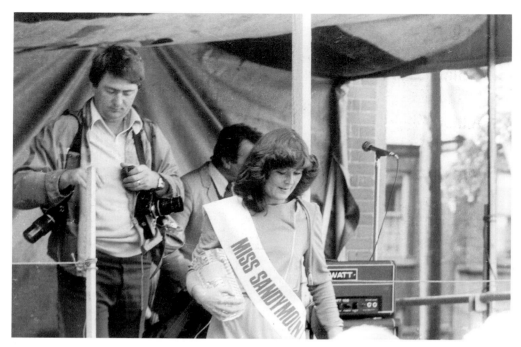

Delia Aherne stepping down from the podium after winning the Miss Sandymount title in 1982.
(Courtesy of Delia Aherne)

A Bloomsday gathering outside the Star of the Sea church, 2012. (Courtesy of Bridie Murphy)

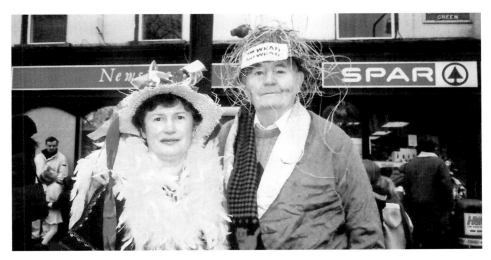

Bridie and Peter Murphy dressed for the part in the Wren Day festivities on Sandymount Green, during the 1990s. The Wren Boys' tradition had started in Sandymount in 1984. The Murphys have lived in Sandymount for many years; Peter, who died in 2011, was well known for his presentation of many sponsored radio programmes and for his subsequent hosting of *Cross Country Quiz* on RTÉ television. Peter was also a noted compiler of crosswords and was compiling newspaper crosswords up to the time of his death. (Courtesy of Bridie Murphy)

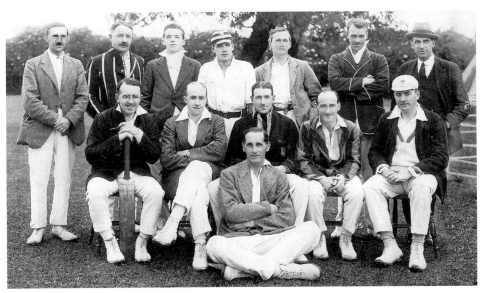

Pembroke Cricket Club, off Park Avenue, is the oldest sports club in Sandymount, dating back to 1868. In 1983, the club bought its grounds from the Pembroke estate and now owns them jointly with the Monkstown Football Club. The entrance to the club is opposite St John's church, but to avoid confusion with Railway Union on the other side of Park Avenue, the address of the Pembroke club is often given as Sydney Parade. The club has six men's teams, two ladies' teams and five schoolboy league teams. This photograph shows its cricket team assembled for a match in 1922. (Courtesy of Pembroke Cricket Club)

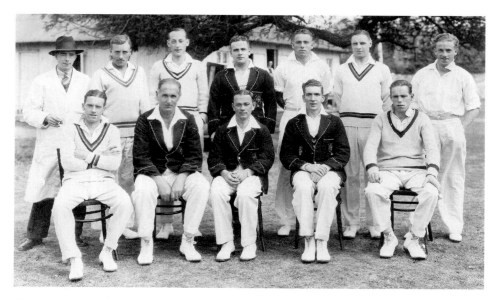

The Pembroke Cricket Club first XI during the 1933 season. From left to right, back row: B.C. Harper, F.H.C. Salmon, R.P. Tanham, W.F. Aylward, M.B. Williams, H.P. Beamish and S.G. Murphy; From row: L.P. McCarthy, A.D. Cordner (vice captain), A.G. Murray (captain), T.F. Ward and T.C. Williams. (Courtesy of Pembroke Cricket Club)

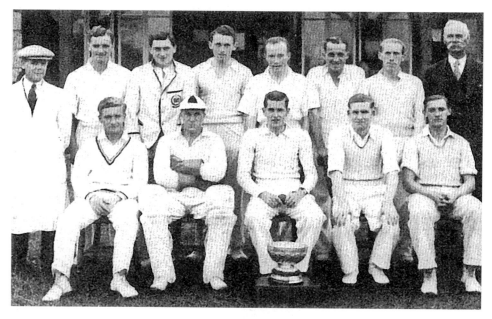

The Railway Union sports club was set up in 1904 by the various railway and steam packet companies then operating in Dublin, to provide sporting and social facilities for their workers. This photograph shows the 1939 XI cricket team. The team had just won the Intermediate Cup and League Division B. The team had two of the Tanham brothers, while another played for Pembroke. (Courtesy of Railway Union)

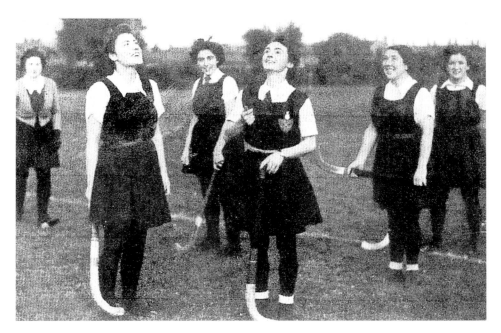

The Railway Union senior ladies hockey team, 1942. The ladies' hockey section in the club had been formed in 1919 and today is still going strong, with half a dozen teams. This photograph shows the team entering senior ranks, with Mrs Kyrie Tanham tossing the coin for the first game, against Civil Service, at the Park Avenue grounds. (Courtesy of Railway Union)

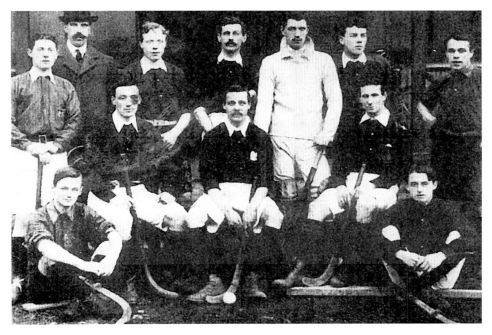

The Railway Union hockey club first XI, 1910/11. The men's hockey club at Railway Union dates from 1904, the year that Railway Union was founded. (Courtesy of Railway Union)

Mick Dempsey receives the Goulding Cup for junior rugby from CIE general manager Frank Lemass, then president of Railway Union, 1961. (Courtesy of Railway Union)

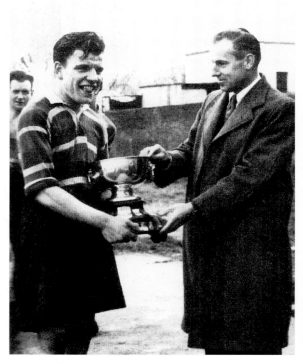

The Railway Union's first tennis team, 1934. (Courtesy of Railway Union)

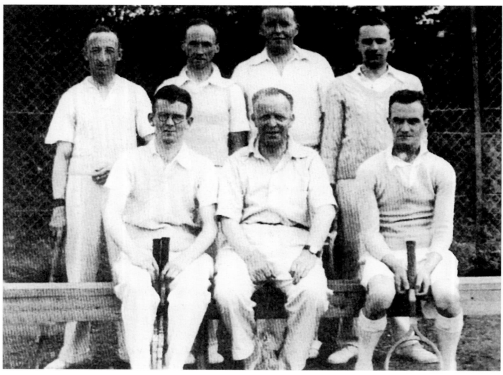

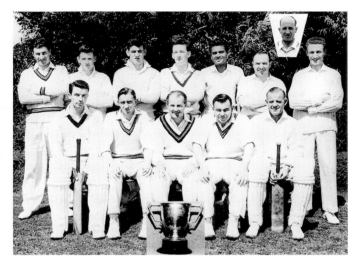

The Railway Union First XI, winners of the Leinster Senior League, 1960. From left to right, back row: G.P. Harvey, B.A. O'Brien, L.A. Behan, J.E. Pigot, H. Singh, N. Fitzsimons, D.F. Byrne; Front row: D.E. Page, G.W. Connolly, Derek Scott (captain), N.F. McConnell, K.P. Dempsey; Inset: J.V. Tanham. Derek Scott went on to become honorary secretary of the Irish Cricket Union, 1974-1997 and president in 2001. He died in July 2015. Brendan (Ginger) O'Brien, from Gilford Road, gained 52 caps and was captain of Ireland. He holds the all-time Leinster record of 21,765 runs in 705 games. Jack Tanham was one of the ten members of the Tanham family from Park Avenue who played senior cricket for Railway Union between 1940 and 1991. (Courtesy of Dr Francis X. Carty)

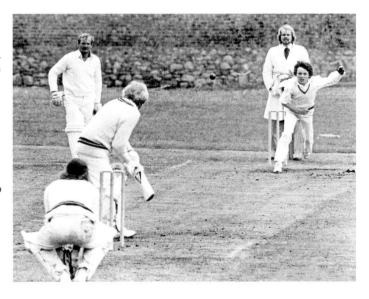

Two famous Sandymount cricketers seen in action in 1978, with Alan Lewis (right) bowling to his father, Ian (left). Ian, who died just over a decade ago, aged 69, lived all his life at No. 65 Sandymount Road; his parents were Tom and Eileen. Alan went on to play 121 times for the Ireland cricket team between 1984 and 1997. He captained Ireland on thirty-five occasions and in playing for Ireland, he scored 3,579 runs. He is now an international rugby referee. Alan is also the treasurer of the YMCA Cricket Club, based in Claremont Road. Over recent decades, the club has enjoyed many highlights in Irish cricket, including two presidents of the Irish Cricket Union. In 1992, the club's A.R. Dunlop scored 1,000 runs during a remarkable season. Today, the club has five teams at XI level, two women's XI teams, nine junior boys' teams and two junior girls' teams. The current clubhouse and pavilion were opened in 2005. (Courtesy of Alan Lewis)

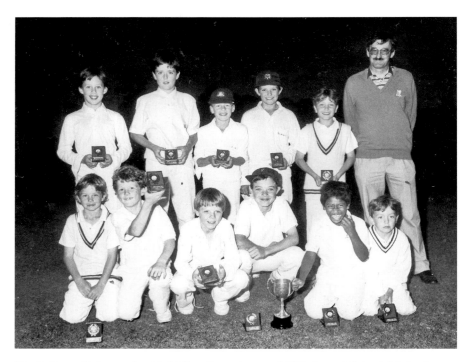

The Railway Union under 11 Molins Cup winners, 1992. From left to right, back row: Neil Davitt, Gerard Foster, Kenny Carroll, Gregory O'Meara, Patrick Boland, Brian Donnelly (coach); front row: Conor Mullen, Kevin O' Brien, Niall O' Brien, Roger Whelan (captain), Graham Austin, Michael Boland. Niall and Kevin O'Brien and Roger Whelan have played as senior internationals for Ireland and Kenny Carroll is a dual cricket and hockey international. Conor Mullen was capped for Ireland at Senior A level. Gregory O'Meara is son of Joey O'Meara (1943- 2001), who was also a dual international in cricket and hockey. Joey was Railway Union's leading cricket all-rounder, with 7,769 runs and 370 wickets in 411 games between 1959 and 1991. (Courtesy of Dr Francis X. Carty)

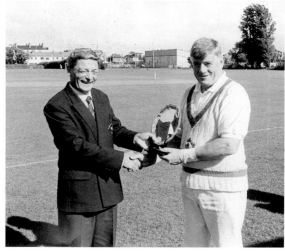

Captain Brendan (Ginger) O'Brien receives the Belevedere Bond League Shield in 1994 from Enda McDermott, president, Leinster Cricket Union, at the Railway Union grounds in Park Avenue. (Courtesy of Dr Francis X. Carty)

9

WELL-KNOWN
RESIDENTS

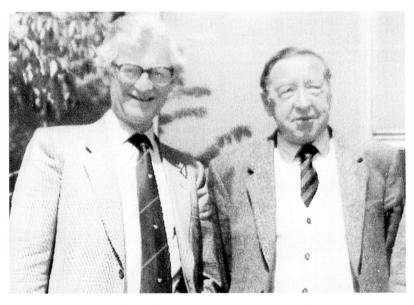

Eddie MacSweeney (right), whose stage name was Maxwell Sweeney, worked as a producer on RTÉ Radio 1 for many years. He produced *Sunday Miscellany*, one of the longest-running Irish radio shows, which started in 1968. Eddie began his media career as a reporter with *The Irish Times*, then was closely involved with that newspaper's spin off, *The Times Pictorial Weekly*. After the Second World War, he moved into cinema publicity, including a spell at the Rank studios in Denham, Buckinghamshire, during the era of the Rank starlets. In the photograph, a colleague, Paddy O'Neill, is on Eddie's left; after Eddie's death, he took over as producer of *Sunday Miscellany*. Two other noted media personalities who had close associations with Sandymount were Vere Wynne-Jones, who died in 2006, and Ella Shanahan, who died in 2011.

Noel Purcell, a well-known actor, lived in Sandymount for many years, until his death in 1985. Born in Lower Mercer Street in the city centre in 1900, he was educated by the Christian Brothers in Synge Street and became a carpenter. While working on scenery for stage production, he became interested in acting and went on to appear in nearly sixty films, including *Mutiny on the Bounty* and *Moby Dick*. His last film was made in 1973. He and his wife Eileen Marmion married in 1941 and went on to have four boys. They lived for 15 years at No. 2 Newbridge Drive in Sandymount. After several subsequent moves in the area, they ended up living at No. 4 Wilfield Road.

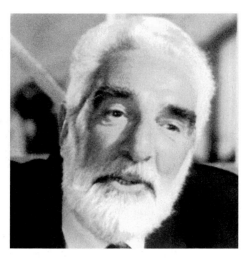

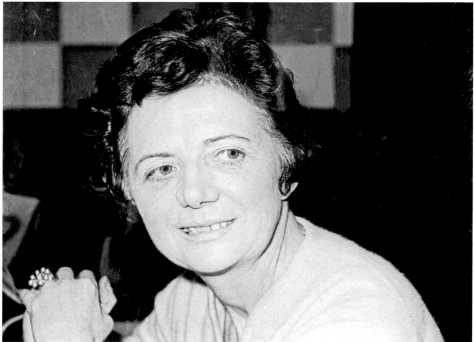

Long-time Sandymount resident Brid Mahon, who was renowned for her work with the Irish Folklore Commission. When it was transferred from Merrion Square to UCD in Belfield, she followed. Born in 1922, she was also a prolific scriptwriter for Radio Éireann, writing some 500 scripts in total for the station, which is now RTÉ. She was also a longstanding columnist for the old *Sunday Press* newspaper. She also wrote books on various subjects, such as Irish food and dress. Her younger sister, Brenda Maguire, was also a noted newspaper columnist. For many years, the family home, where Brid lived, was at Claremont Park in Sandymount. She died in February 2008. (Courtesy of National Folklore Collection/UCD)

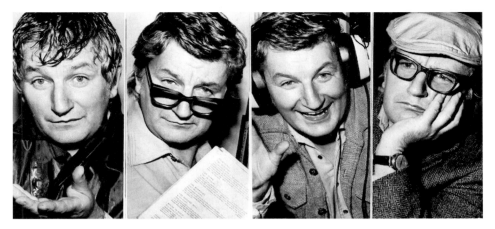

The well-known Irish actor, T.P. McKenna, who died in 2011. A native of County Cavan, his first job was with the Ulster Bank before he made his breakthrough into acting. He went on to become a noted actor of his generation. From 1959 until 1972, he and his family lived in a splendid house at No. 36 Sandymount Avenue, built in the early nineteenth century by the same builder who had constructed many of the houses in Claremont Road that were built as accommodation for army officers and their families. (Courtesy of Stephen McKenna/steviepics photography.com)

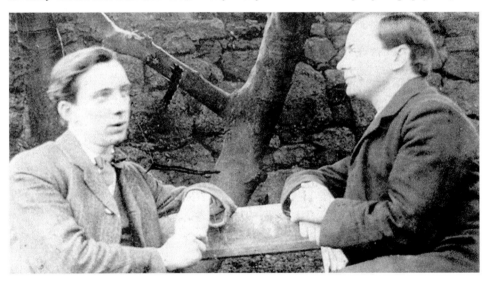

Willie (left) and Padráig Pearse in Sandymount. The Pearse family lived above their monumental stoneworks in what is now Pearse Street until they moved to Newbridge Avenue in 1884. At that stage, one of their sons, Padráig, who became famous for his part in the 1916 Easter Rising, was just 5 years old. The family stayed in Newbridge Avenue for a decade before moving to No. 5 George's Villas on Sandymount Avenue. Tragedy struck in September 1900 when James Pearse, the father, was visiting his brother in Birmingham and died there from a cerebral haemorrhage, aged 60. At 1901, the family moved to a smaller house on Lisreaghan Terrace on Sandymount Road. In their new address, the Pearses dispensed with the number of their house and the name of the street where they lived, so they simply listed their address as Liosán, Sandymount.

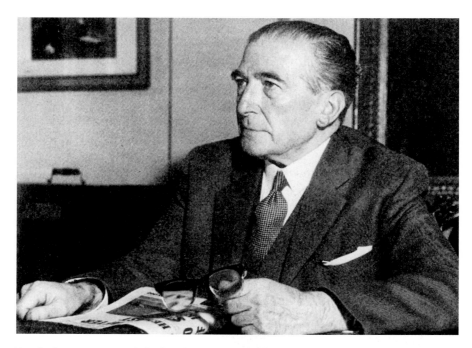

Frank Geary was one of the best-known journalists of his generation. From Kilkenny, he had joined the *Irish Independent* in 1922 and was made editor thirteen years later. He remained editor until his retirement in September 1961. He had long planned to write his memoirs when he retired, but he died in December that year. His wife Maureen, who came from County Meath and was a nurse at the old Jervis Street hospital, survived him by many years, dying in July 2010 at the age of 98. For many years, the Gearys lived at No. 28 Claremont Road, Sandymount, with their four children, Frank, Paddy, Isabel and Tom. (*The Newspaper Book* by Hugh Oram)

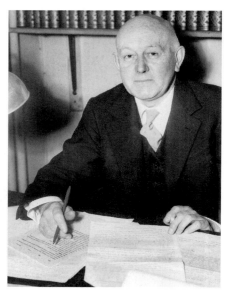

Another distinguished national newspaper editor who lived in Sandymount was Francis Carty, who was a one-time editor of the old *Irish Press*, from 1957 until 1962, when he was made editor of the old *Sunday Press*; he retired in 1968 and died four years later, in 1972. He married Alice Quinn in 1934 and they went on to have three children, Jane, Ciarán and Francis. From 1940 until the present, the family home has been in Sandymount Avenue, where one of Francis Carty's sons, Dr Francis X. Carty, still lives. (Courtesy of Dr Francis X. Carty)

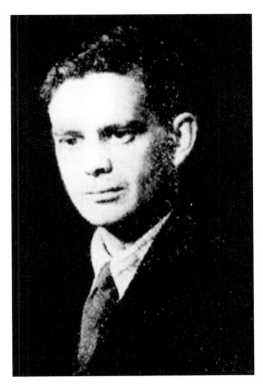

Valentin Iremonger, a noted poet of international reputation, who had close connections with Sandymount. He was an Irish ambassador who held various posts, including India and Sweden, but he often wrote of Sandymount. One of his best-known works was the poem 'Horan's Field', which he knew when growing up. It was behind the Star of the Sea church, and Beach Drive now occupies it.
(Courtesy of Rún Press/Sheila Iremonger)

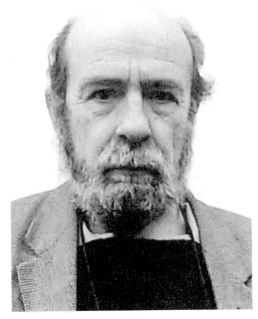

The founder and former editor and publisher of Books Ireland, Jeremy Addis, has lived in Newgrove Avenue, Sandymount, for many years. When he was working at the Kilkenny Design Centre in 1976 he started the magazine, then in the late 1980s, he and his wife Deirdre moved from County Kilkenny to Sandymount. Deirdre, a special needs teacher, was a familiar figure around Sandymount village. Robert Greacen, a well-regarded poet who spent his last years in Sandymount, was a frequent contributor to Books Ireland. Born in Derry, his first poetry collection was published when he was 21 and he went on to produce many more such collections. At the end of 2013, Jeremy ceased publishing Books Ireland, which was soon acquired by Wordwell publishers; he continues to contribute to the magazine.
(Courtesy of Wordwell/Books Ireland)

Christopher Casson, a noted actor, lived for many years on Strand Road, Sandymount. Born in Manchester in 1912 to a celebrated theatrical couple, Dame Sybil Thorndike and Sir Lewis Casson, Christopher came to Dublin in 1938 to join the MacLiammóir/Edwards company at the Gate Theatre. In 1941, he married Kay O'Connell, a noted artist and stage designer. Five years later Christopher moved to another company based at the Gate Theatre, Longford Productions. In 1950, he became a freelance actor for television, films, radio and stage. When he joined the cast of the *Riordans*, an RTÉ television soap, he achieved national recognition as Canon Browne, the Church of Ireland rector. He continued acting until shortly before his death in July 1996, at the age of 84. The painting was done in 1941 by Harry Kernoff.

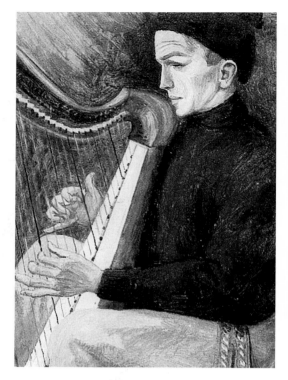

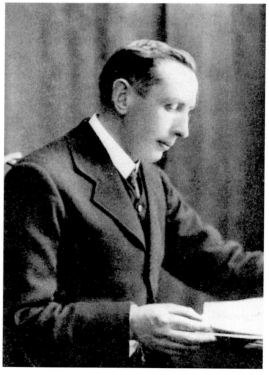

T.C. Murray, one of the outstanding early twentieth-century playwrights in Ireland, lived at No. 11 Sandymount Avenue for many years. Born in Macroom, County Cork, in 1873, he became a schoolteacher. His first play was produced in Cork in 1909 and he was a co-founder of that city's Little Theatre. When his play, *Birthright*, was performed at the Abbey Theatre in Dublin in 1911, it established him as a playwright of note. He went on to write fifteen plays, the most famous of which was *Autumn Fire*, which became the first full-length Irish play to be televised in the US.

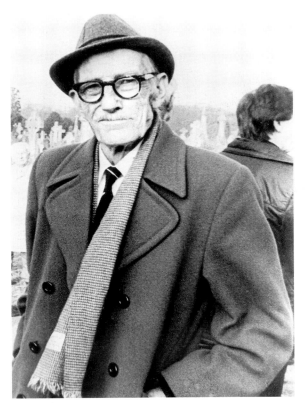

Kevin O'Rorke was very well known around Sandymount as he was a Garda Síochána and also a long-time member of the Old Dublin Society. He lived in Newbridge Avenue, where many of the houses had been built by his grandfather. He served in the Garda Síochána from the 1930s to the 1970s, at a number of stations in the city, including Irishtown. His speciality was recovering stolen property and he also had a spell on protection duty at Áras an Uachtaráin. When he was in the Garda Síochána, his nickname was 'Red Ronnie'. His strong voice made him an ideal candidate for his other job, doing historical walking tours of Sandymount and other areas. He died in 1991.
(Courtesy of Brian Siggins)

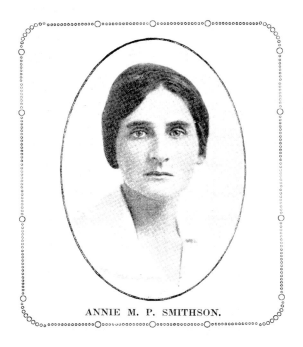

ANNIE M. P. SMITHSON.

In her heyday, Annie M.P. Smithson was as well known as any chick-lit author today. Her novels sold in vast quantities, but today she is almost forgotten. Born in 1873, she was brought up in Claremont Road. Annie became a nurse and for many years was secretary and organiser of the Irish Nurses Organisation. When she was 34, she converted to Catholicism and became a fervent supporter of Sinn Féin. Her first novel, *My Irish Heritage*, was published in 1917 and became an immediate best-seller. She went on to publish a total of twenty novels and two short-story collections, all highly romantic. She died in 1948. (Courtesy of the National Library of Ireland)

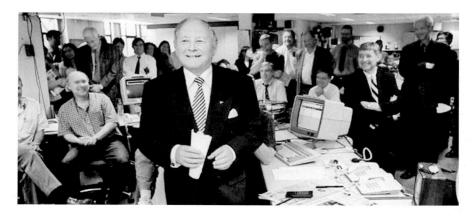

Louis O'Neill, a former group managing director and chief executive of *The Irish Times*, and a native of Sandymount. He was born in Sandymount in 1931, the youngest of the three children of Christopher and Margaret O'Neill. He began his education at the Star of the Sea national school, before going on the Christian Brothers in Westland Row. He qualified in accountancy and went on to work for two financially troubled publications, the *Radio Review* and the *Dublin Evening Mail*. Both were taken over by *The Irish Times* but neither survived. Louis continued working for that paper, for 42 years in all. During Louis' tenure of office, *The Irish Times* brought many improvements to its production, including colour printing. (Courtesy of *The Irish Times*)

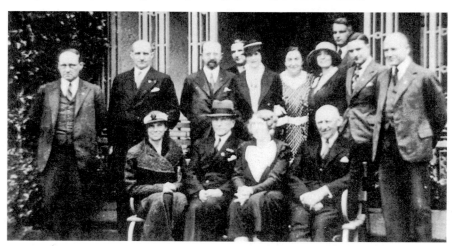

In the years just before the Second World War, Ireland had an active branch of the Nazi Party. Members had their Christmas parties at the Gresham Hotel, and they also visited the Kilmacurragh Hotel in County Wicklow. Functions were often held at the long-vanished Red Bank restaurant in D'Olier Street. This photograph, taken on 4 May 1935, shows a birthday party at the Sandymount home of Colonel Fritz Brase, one of the leading lights of the Nazi party in Ireland. The group are formally dressed and include standing, left to right, Adolf Mahr, then director of the National Museum of Ireland; Otto Bene, head of the Nazi Party in London and Oswald Mueller-Dubrow, a director of the Siemens company, which had built the Ardnacrusha hydro-electric dam on the River Shannon. (Courtesy of History Ireland)

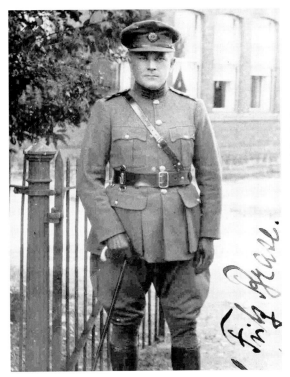

Colonel Fritz Brase came to Ireland from Germany in 1923 to become the first director of the army's school of music. He rearranged many Irish tunes to make them sound like Prussian marching music. In the early 1930s, he got into difficulties with the chief of staff when he asked permission to set up a branch of the Nazi Party in Ireland. The idea of a colonel in the Irish Army swearing allegiance to the Third Reich was out of the question, but Brase went ahead anyway, joining the Nazis in April 1932. However, pressure from his military bosses forced him to resign from the Nazis 2 years later. He died at his home in Sandymount in 1940, aged 65.
(Aloys Fleischmann estate)

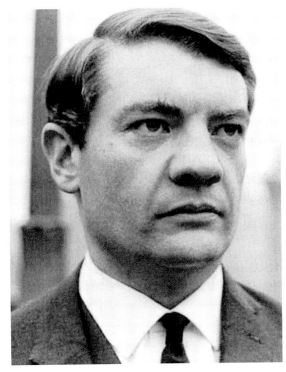

Dr David Thornley had a remarkable career as a Trinity College academic, a television presenter with RTÉ and as a Labour TD. He had an outstanding career at Trinity College, starting as a student and becoming a professor. From the mid-1960s, he also worked as a presenter on *Seven Days* on RTÉ television. He also became very involved in left-wing politics and in 1969, although he lived in Sandymount, topped the poll in Dublin North-West as a Labour Party TD. He remained in the Dáil until 1977, by which time he had also been an MEP for 4 years, spending much time in Strasbourg. An intellectually gifted man of prodigious talents, he sadly died in 1978 at the young age of 43. (Courtesy of RTÉ/Yseult Thornley)

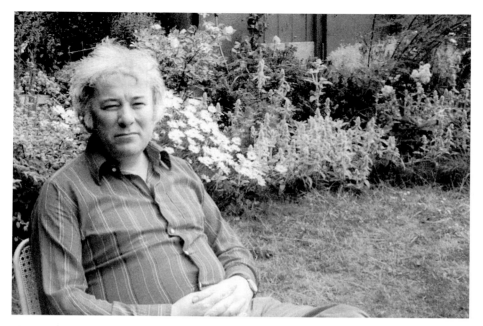

The late Séamus Heaney, seen in the back garden of the family home at Strand Road. A native of County Derry, he graduated from Queen's University, Belfast. While still young, he started to build an enviable reputation as a poet. Moving south in 1972, he was appointed head of the English department at Carysfort teacher training college in Blackrock. His poetry output was prodigious and he won much worldwide acclaim, including the Nobel Prize for Literature in 1995. He later lived on Strand Road with his wife Marie Devlin and he could be seen on occasion on the walkway at Sandymount Strand. By the time of his death, in 2013, at the age of 74, he was well recognised as the greatest poet Ireland had produced since W.B. Yeats, as well as being the best-known poet in the world. (Courtesy of Marie Devlin)

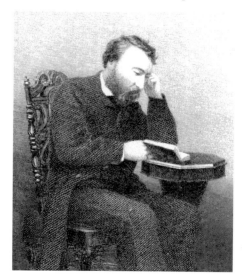

Charles Kickham, the noted nineteenth-century nationalist writer, had a close connection with Sandymount. Born in County Tipperary in 1828, he became a Fenian activist, as well as a novelist, poet and journalist. In September 1865, when the police discovered a Fenian rising was being planned, Kickham went into hiding. But early in the morning of 11 November 1865, along with Fenian leader James Stephens, Kickham was captured at Fairfield House in Newbridge Avenue, Sandymount. Stephens had been living there under a false name, as 'Mr Herbert', who claimed to be a keen horticulturalist. Kickham was imprisoned but was released after serving just over three years, on grounds of his ill health. He died in 1882.

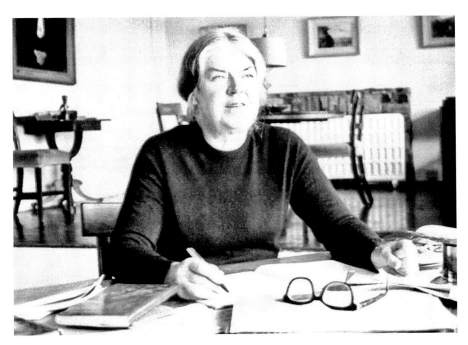

Yet another twentieth-century writer who had close links with Sandymount, Mary Lavin. She had been born in Massachusetts in 1910 to Irish immigrants, but the family returned to Ireland when she was 10. When she was a young woman and before she married her first husband, William Walsh, a lawyer, she lived in Sandymount. Later in life, she had a farm at Bective, County Meath and finally, a mews house at Lad Lane off Lower Baggot Street. Her daughter, Caroline Walsh, was a former literary editor of *The Irish Times*.

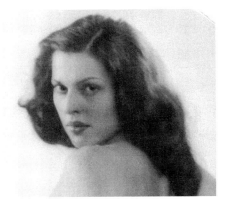

Long-time Sandymount resident Agnes Bernelle was born in Berlin in 1923 as Agnes Bernauer. Her family fled Nazi Germany in 1936 and she lived for many years in the UK, making a name for herself appearing in cabaret and over twenty films. In 1945, she married Desmond Leslie from Castle Leslie in County Monaghan. The stormy marriage lasted until 1969; her subsequent husband was Maurice Craig, the architectural historian and author, and they lived for many years in a decadent, picture-filled house on Strand Road, Sandymount. Agnes Bernelle died in 1999.

Another actor who had close ties with Sandymount was Dermot Morgan, who at one stage spent several weeks living in what is now the Sandymount Hotel. Morgan was born in 1952 and started his working life as a teacher in St Michael's College in Ailesbury Road, Ballsbridge, before breaking into comedy acting. Dermot's main claim to fame was the *Father Ted* series on Channel 4, which started in 1995. In 1998, when he had just finished filming the third and final series, he died from a heart attack.

The house at No. 5 Sandymount Avenue where W.B. Yeats was born in 1965 and the plaque on the front wall of the house.

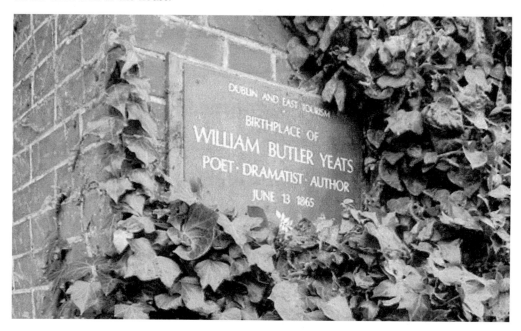

In recent years, the anniversary of the birth of W.B. Yeats has been commemorated by events in the village. Locally based author Anthony J. Jordan has been closely involved with these commemorative events. (Courtesy of Anthony J. Jordan)

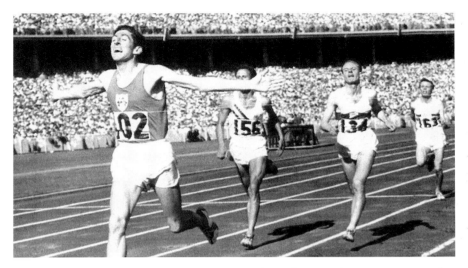

Ronnie Delany seen winning the 1,500 metres at the Melbourne Olympics on 1 December 1956. Ronnie, with his gold medal, became a legend in his lifetime at the tender age of 21. He lived at St John's Road in Sandymount until he got married. He worked for many years for the old B+I shipping company and subsequently set up his own marketing company. He now lives at Carrickmines in south County Dublin but still keeps in touch with his Sandymount connections.

One of the most familiar faces on RTÉ television, Bryan Dobson, being interviewed in 2013 outside Browne's café on Sandymount Green for *News Four*. Bryan was brought up in Farney Park and began his broadcasting career with a pirate station, Radio Nova, in his early 20s. Then in the mid-1980s, he spent a couple of years as a presenter with the BBC's Radio Ulster in Belfast. He returned home to Dublin and was appointed to RTÉ, where he has been ever since, working as a co-presenter on the *Six One* television news for over fifteen years. Now aged 54, he is also Adjunct Professor of Public Service Broadcast Journalism at the University of Limerick. (Courtesy of News Four)

For many years, Anthony J. Jordan was the headmaster of the school for disabled children where Enable Ireland now stands at the foot of Sandymount Avenue. Since his retirement from that job, he has written many biographies of well-known people in Irish life. He is seen here with fellow Mayo man Enda Kenny, An Taoiseach, in the 2011-2016 government. (Courtesy of Anthony J. Jordan)

Ann Ingle, when she was the editor of *News Four*, a role she held for six years. She and her family lived for many years in a house on the Methodist church side of Sandymount Green. Her daughter, Róisín, started on *News Four* and has since gone on to become one of the best-known journalists on *The Irish Times*. *News Four* began at No. 12 Seafort Avenue, around twenty years ago, in what had been the premises of McDonnell's old dairy. Up until the 1950s, Sandymount had a number of dairies, with others in Serpentine Avenue and Tritonville Road. *News Four* is now based in Ringsend. (Courtesy of News Four)

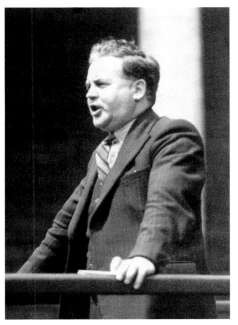

William Norton, a key figure in the Labour Party, had close connections with Sandymount. He was born in 1900 at No. 21 Bath Avenue; his father Patrick was a tram driver who changed jobs to become a postman. William spent many years as general secretary of the Post Office Workers' Union, now the Communication Workers' Union. Elected a Labour Party TD in 1926, he remained in the Dáil until 1964. He was also leader of the Labour Party from 1932 until 1960. He died on 4 December 1963, at his home in Merlyn Park, Ballsbridge, and his funeral took place at the Star of the Sea church. Other Labour Party TDs with Sandymount connections have included Dr David Thornley, Kevin Humphreys and Ruairi Quinn. Today, fittingly, the Sandymount Credit Union is only a few doors away from Norton's birthplace. It was founded in 1961 in a lane off Londonbridge Road and has occupied its present premises at Bath Avenue since 1977.

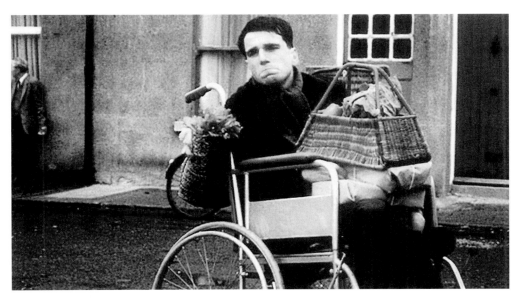

Daniel Day-Lewis seen here in his role of Christy Brown, the writer and artist who could only type or paint with his big toe. Day-Lewis, famed for thinking himself into every role he plays with absolute zeal, spent six weeks at the Cerebral Palsy school in Sandymount, getting into the persona of Christy Brown. The film was shot over nine weeks at Ardmore Studios in Bray, while Daniel Day-Lewis stayed with a fellow thespian in Sandymount, Agnes Bernelle. In 1990, the *My Left Foot* won two Oscars; one for Daniel Day-Lewis and the other for Brenda Fricker, who played Christy's mother, as well as winning a host of other international awards. (Courtesy of Anthony J. Jordan)

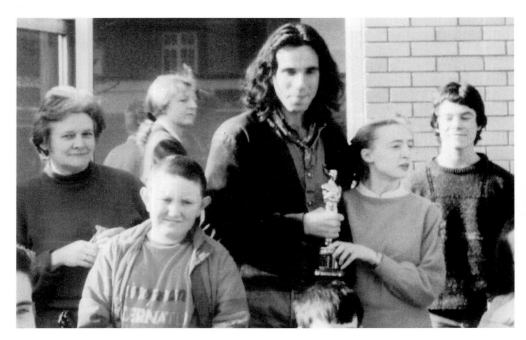

Daniel Day-Lewis, in a photograph taken prior to the filming of the *My Left Foot*. This photo was taken at the former school for disabled children with epilepsy, where Enable Ireland now stands, at the foot of Sandymount Avenue.

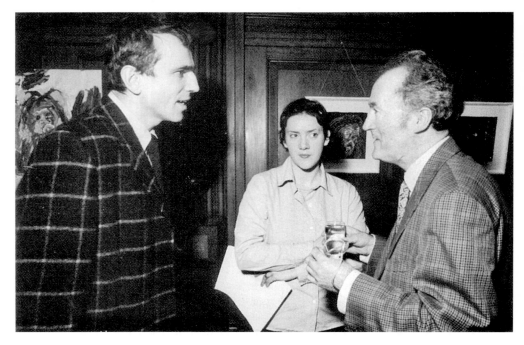

Daniel Day-Lewis with Anthony J. Jordan, who was then the headmaster of the school for children with epileptic disabilities.

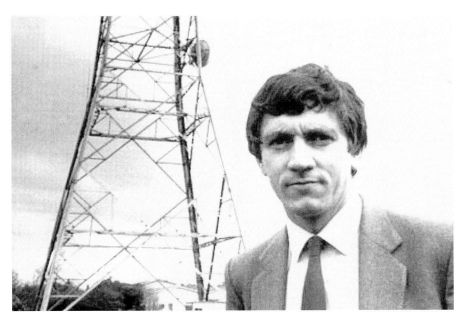

Charlie Bird was born in Sandymount and spent the first five years of his life there. His only recollection of the area from that time is of the stories he has been told of then Sandymount resident, Ronnie Delany, pushing his pram. Charlie began his media career working in the library at *The Irish Times*. He joined RTÉ in the mid-1970s and worked as chief news correspondent for many years, became a familiar on-screen personality every night. He retired from RTÉ in 2012 but is still making television programmes. Another noted contemporary media personality, brought up in Sandymount is Shay Healy. (Courtesy of RTÉ Archives)

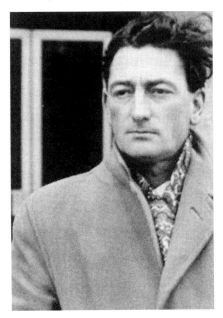

Although the writer James Plunkett was born in Sandymount in 1920, he was raised in Upper Pembroke Street and went to school at Synge Street. His father, a former British Army soldier, was a trade union activist. James Plunkett spent most of his career working in drama at RTÉ, first in radio, then in television. His main claim to fame was his novel, *Strumpet City*. When a London publishing house brought out the book in 1969, Plunkett's advance was reputed to have been the largest ever made to an Irish author: well over £100,000. It was launched in the old Davy Byrne's pub in Dublin city centre.

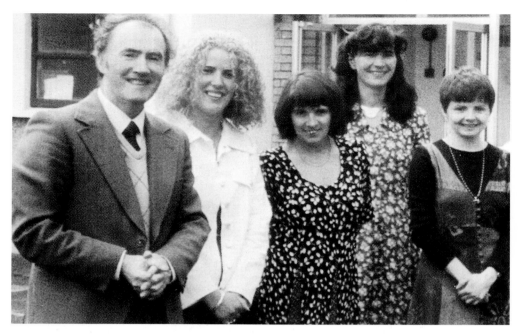

Anthony J. Jordan with members of staff at the Cerebral Palsy school in Sandymount Avenue. In 1996, the Cerebral Palsy organisation changed its name to Enable Ireland. From left to right: Anthony Jordan, Cristine Keirnan, Rosaleen O'Halloran, Joan McNamara and Yvonne Kidd. (Courtesy of Anthony J. Jordan)

OSCAR THEATRE

Presents
THE WORLD PREMIERE OF

DOWN ALL THE DAYS

By
CHRISTY BROWN
Adapted by
PETER SHERIDAN

"Cry then, with the weeping stars from the debris of your life. Cry then, for the unnamable things, unnamably lost down all the speechless years."

The world premiere of the play made from Christy Brown's autobiography took place at the old Oscar Theatre in Serpentine Avenue. That theatrical presentation came close on thirty years after the book's publication in 1954. (Courtesy of Anthony J. Jordan)

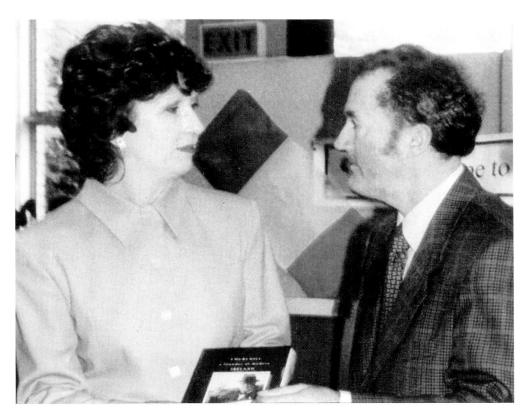

Then President Mary McAleese seen with Anthony J. Jordan at the old cerebral palsy school in Sandymount. (Courtesy of Anthony J. Jordan)

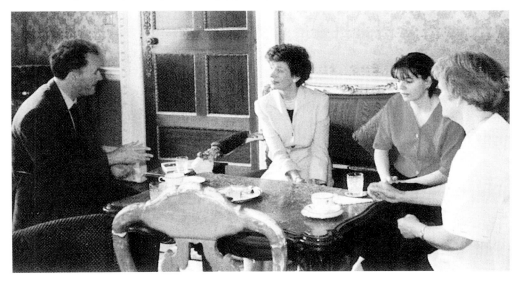

Anthony J. Jordan with another former President, Mary Robinson, also at the cerebral palsy school. (Courtesy of Anthony J. Jordan)

Jack Torpey, a local man who created a sensation when he was elected as an independent councillor on Dublin Corporation in 1967. He was backed by the then new Sandymount & Merrion Residents' Association. Jack Torpey proved an effective councillor, working for the interests of Sandymount residents. He served from 12 June 1967 until 10 June 1974. By day, he worked for Ericssons, the telecommunications company, as the manager of their store in Dublin port. (Courtesy of Mary Torpey)

Local newsagent Harry Mapother worked assiduously for Jack Torpey's election in 1967 and is seen here canvassing (standing right, on the car bumper). The man on the left hasn't been identified. (Courtesy of Mary Torpey)

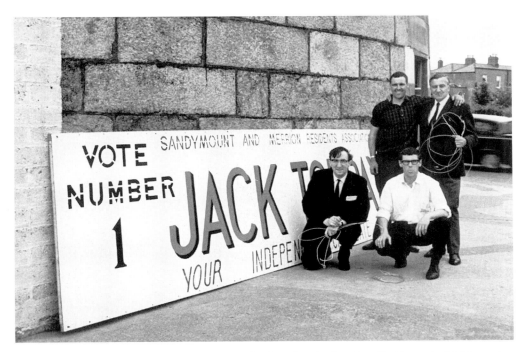

Harry Mapother (nearest the poster) and others beside the Martello Tower in 1967, urging people to vote for Jack Torpey. (Courtesy of Mary Torpey)

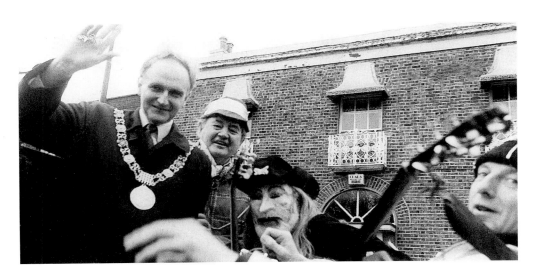

When John Gormley, a former leader of the Green Party, was Lord Mayor of Dublin, he visited the Wren Boys festivities in Sandymount in 1994. He has lived for many years in Ringsend. (Courtesy of Bridie Murphy)

Gerry Thornley, today the rugby correspondent of *The Irish Times*, seen as a teenager in the 1970s. Gerry grew up in Sandymount and his mother and sister still live in the district. (Courtesy of Yseult Thornley)

Mary B. Guckian seen on Sandymount Strand in 1978. For many years, Mary, a native of County Leitrim, worked in the library at the Institute of Public Administration in Lansdowne Road. Since her retirement, she has devoted more of her time to writing poetry and other artistic activities and is well known in Sandymount as an artistic activist. (Courtesy of Mary B. Guckian)

10

HOUSES AND MANSIONS

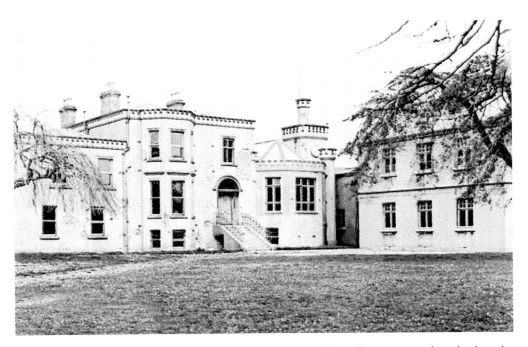

Sandymount Castle was built in early Victorian times, although some say it dates back to the late eighteenth century. During the mid-nineteenth century it was owned by Robert Corbet, a Dublin merchant, who went bankrupt and then committed suicide in 1872. Corbet was an in-law of the Yeats family; the grandfather of W.B. Yeats lived in the house for many years after retiring from his Church of Ireland living. The castle was really a grandiose house with much crenellation and a tower. The houses on the south side of Sandymount Green were formed from part of the castle, whose magnificent gardens were built over in the 1950s to form three roads all named after Sandymount Castle.

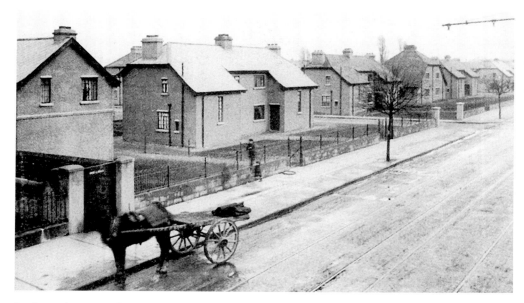

In the mid-1920s, about forty houses for ex-servicemen who had served in the First World War were built along and adjacent to Sandymount Road. The houses were sturdily built by Cramptons and in recent years, many have been extensively refurbished. The ex-servicemen were regarded with some suspicion in Sandymount as some had a reputation for not paying their bills. (Courtesy of Cramptons)

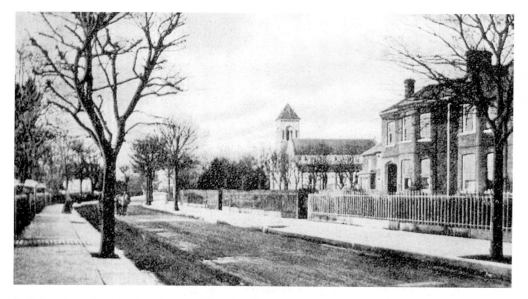

Park Avenue, about 100 years ago. This is still the posh part of the road, extending from Sydney Parade as far as St John's church. The road still contains many large detached houses, including the former home of the late Senator Eoin Ryan, who died in 2001. In this photograph, there are no pedestrians and no traffic, save for a horse-drawn cab in the distance. (Courtesy of the Lawrence Collection/National Library of Ireland)

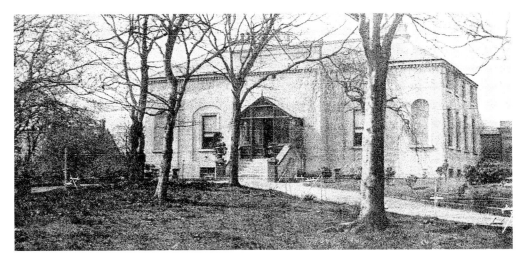

The Gandon villa at Roslyn Park, c. 1900. The building was designed around 1790 by the great Dublin architect of the late eighteenth century, James Gandon, for William Ashford, a landscape painter. It became known as Sandymount Park House and was substantial, with fourteen rooms and a variety of out-houses, including stables, a coach house, a harness room, a cow house and a fowl house. There was also a smaller, adjacent house that had several names in succession, including Roslyn Park and Sandymount Park. The Gandon villa fell into disrepair, but a major renovation programme began in 1988 and was completed three years later. It is still there, as part of the Rehab headquarters.

Oaklands House, Sandymount, which was one of the fine big houses in the area, capacious inside and surrounded by lavish gardens. It was demolished in 1968; two surrounding roads took their names from that of the house. (Courtesy of Lorna Kelly)

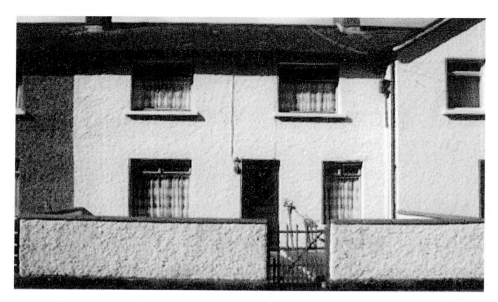

O'Connell Gardens, off Londonbridge Road, were built in 1929 to commemorate the centenary of Catholic emancipation, the leader of which was Daniel O'Connell. The houses in the estate are still in good condition and many have been refurbished in recent years. However, they are overshadowed by the nearby Aviva Stadium. Among the residents is Brian Siggins, a former laboratory technician at the 'tech' in Ringsend and now well known as a local historian. He lives in O'Connell Gardens with his wife, Maureen.

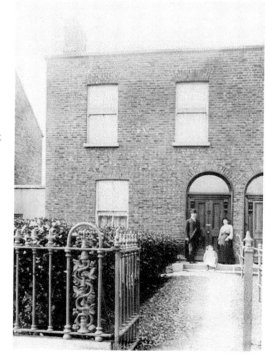

No. 7 Newbridge Avenue, seen in 1890, just after the Grant family had moved in. Tipperary man Thomas Grant had joined the Dublin Metropolitan Police when he was 21 and eventually became an inspector; he retired in 1912. He had married his wife Marie in Portarlington in 1890 and they went on to have five children, although two died in early childhood. Marie died in 1922, eighteen years before her husband. They spent a decade in this house in Newbridge Avenue before moving to Church Avenue, Irishtown, for a year. Then they moved to Rathgar, where Thomas lived until his death in 1940. (Courtesy of grantonline.com)

The site off Gilford Road, donated by the Irish Sisters of Charity to St Vincent de Paul for the construction of the Bethany House complex for elderly people. The photograph was taken in 1980 and in the background can be seen the Windermere apartments on the far side of Gilford Road. (Courtesy of Caritas/Irish Sisters of Charity)

FURTHER READING

Jason Bolton (ed.), Tim Carey, Rob Goodbody and Gerry Clabby, *The Martello Towers of Dublin* (Dublin, 2012)

D.A. Levistone Cooney, *A Tale of Three Churches: A Story from Dublin 4* (2014)

Ruth Dudley Edwards, *Patrick Pearse: The Triumph of Failure* (London, 2007)

Anthony J. Jordan, *Christy Brown's Women* (Dublin, 2008)

Anthony P. Jordan, *The Good Samaritans: Memoir of a Biographer* (Dublin, 2008)

Paul Magee (ed.), *A Social and Natural History of Sandymount, Irishtown, Ringsend* (Dublin, 1993)

Denis McKenna (ed.), *The Roads to Sandymount, Irishtown, Ringsend* (Dublin, 1996)

Yseult Thornley (ed.), *Unquiet Spirit: Essays in Memory of David Thornley* (Dublin, 2008)

Marc Zimmermann, *The History of Dublin Cinemas* (Dublin, 2007)